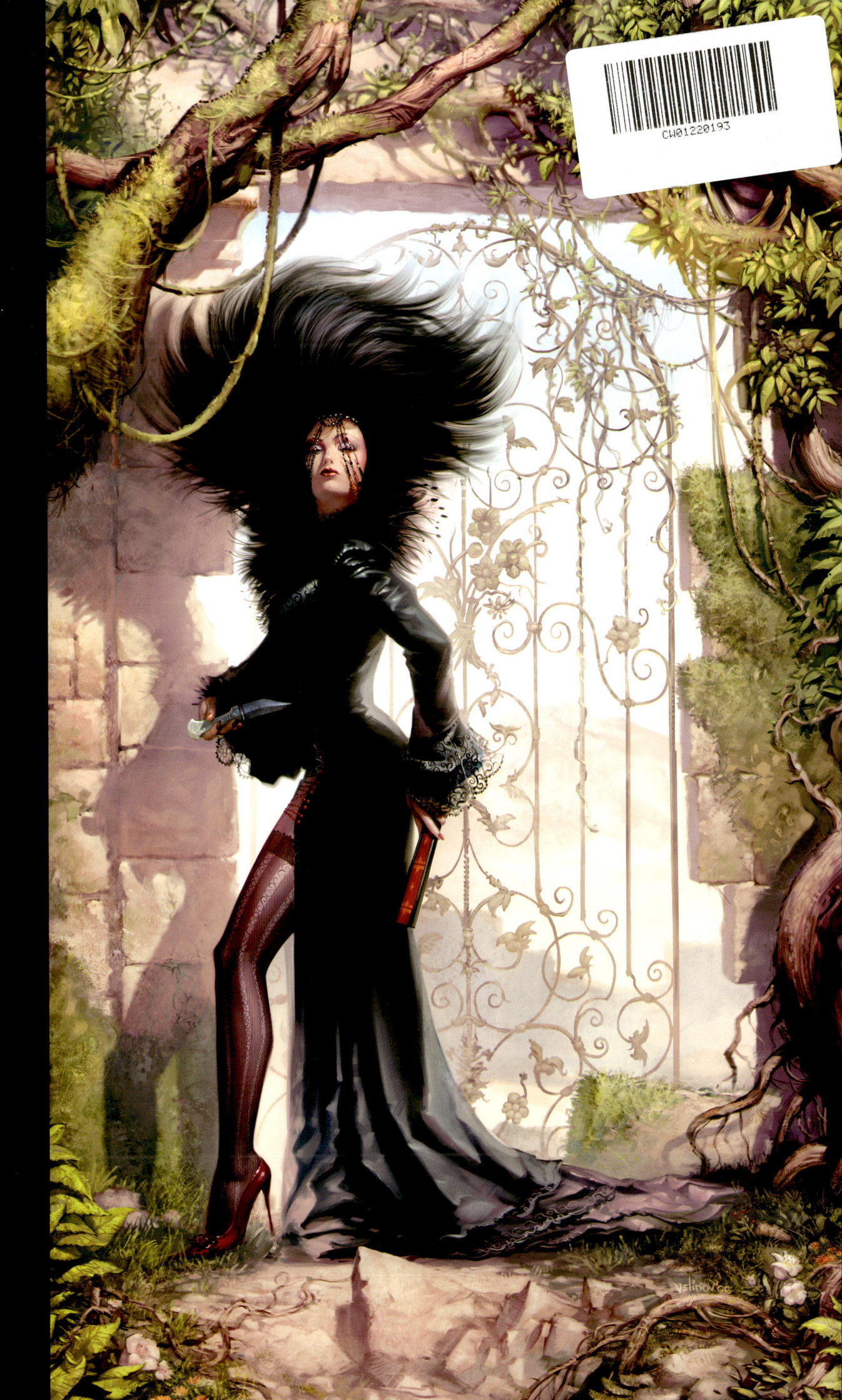

Mistress of water
Photoshop, Maya
Steve Argyle, USA

Lover
Photoshop
Fan Yang, USA

Death on snow
Photoshop
Fan Yang, USA

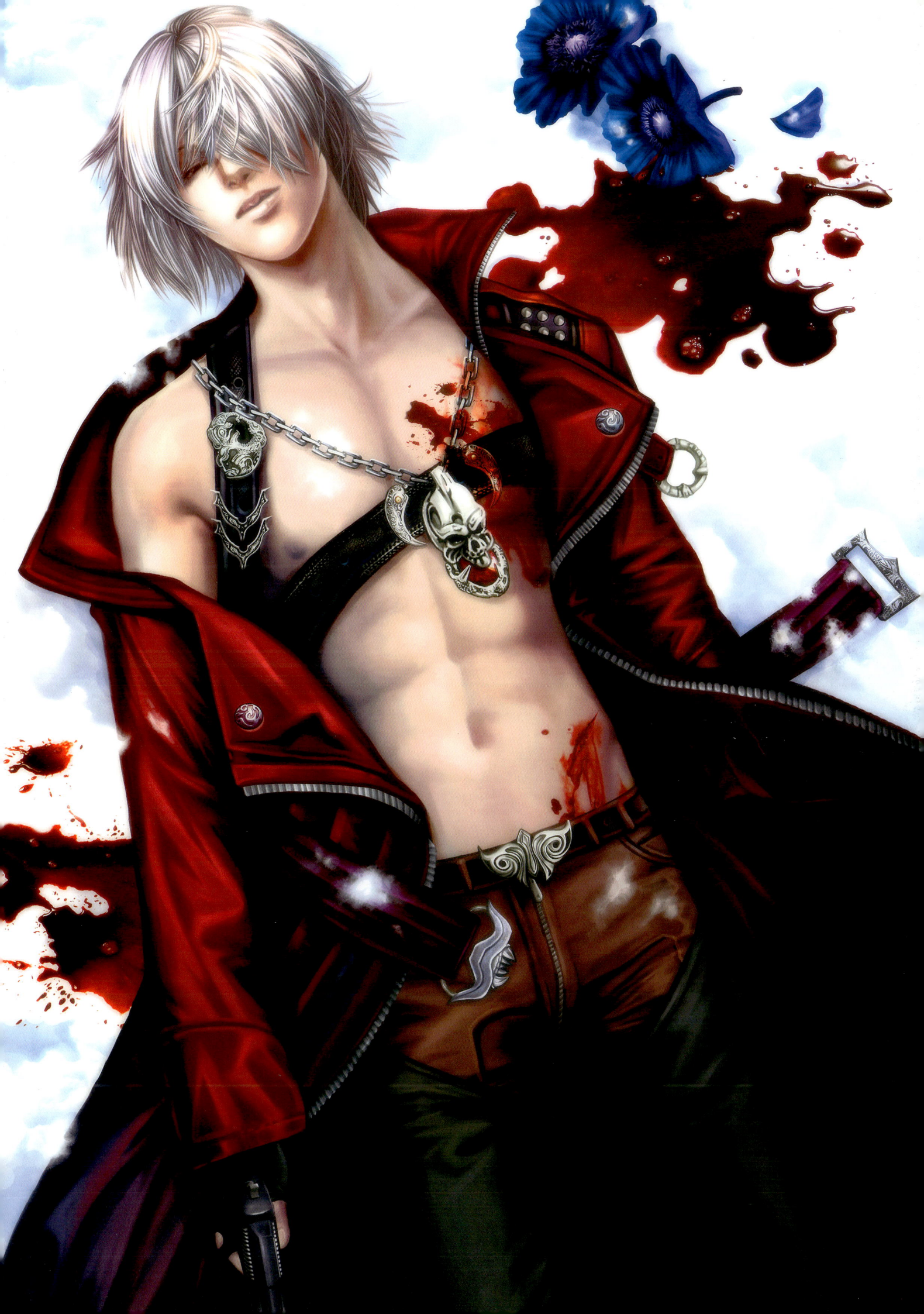

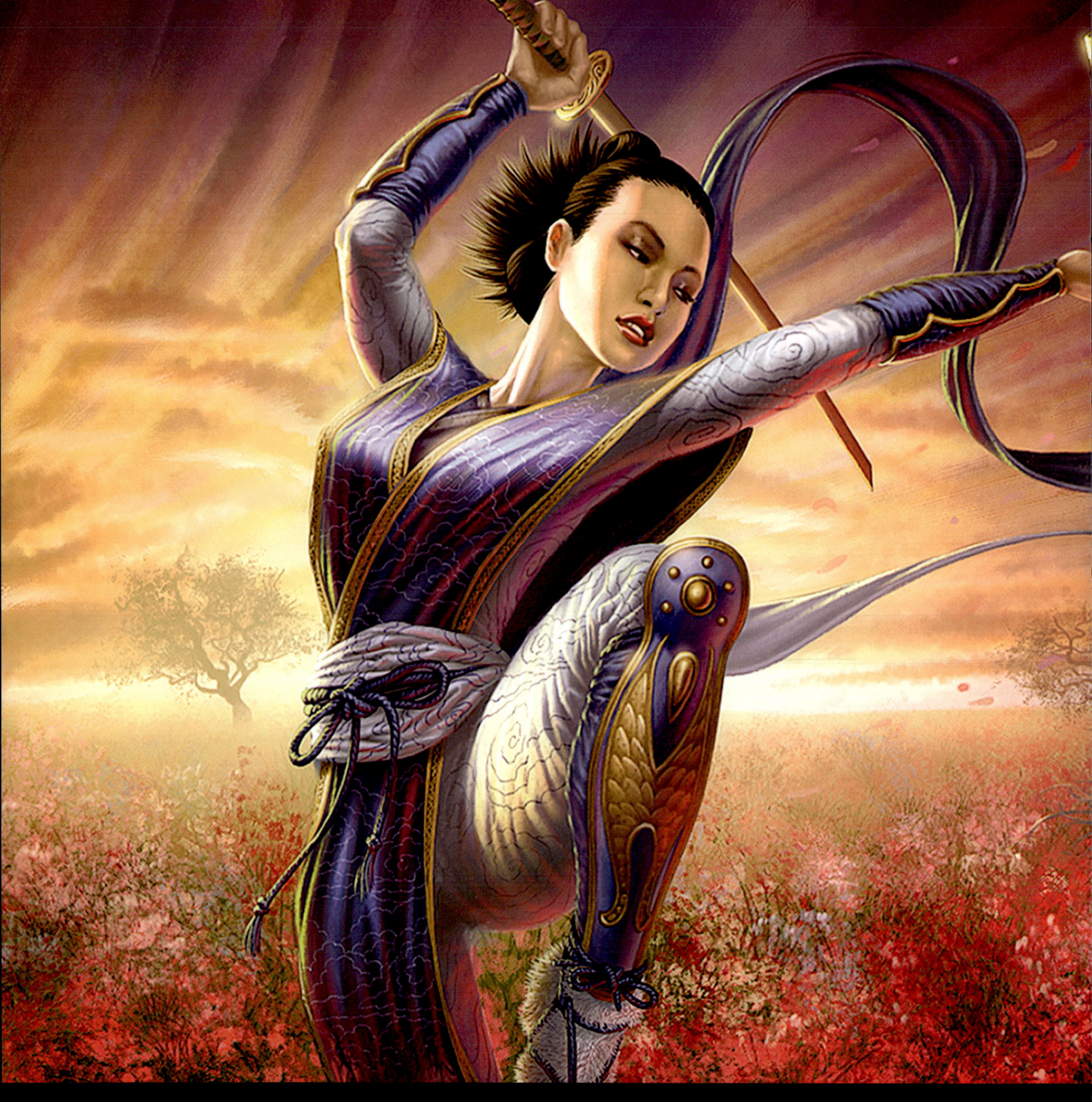

Keeper of air
Photoshop, Painter
Steve Argyle, USA

Broken Flame

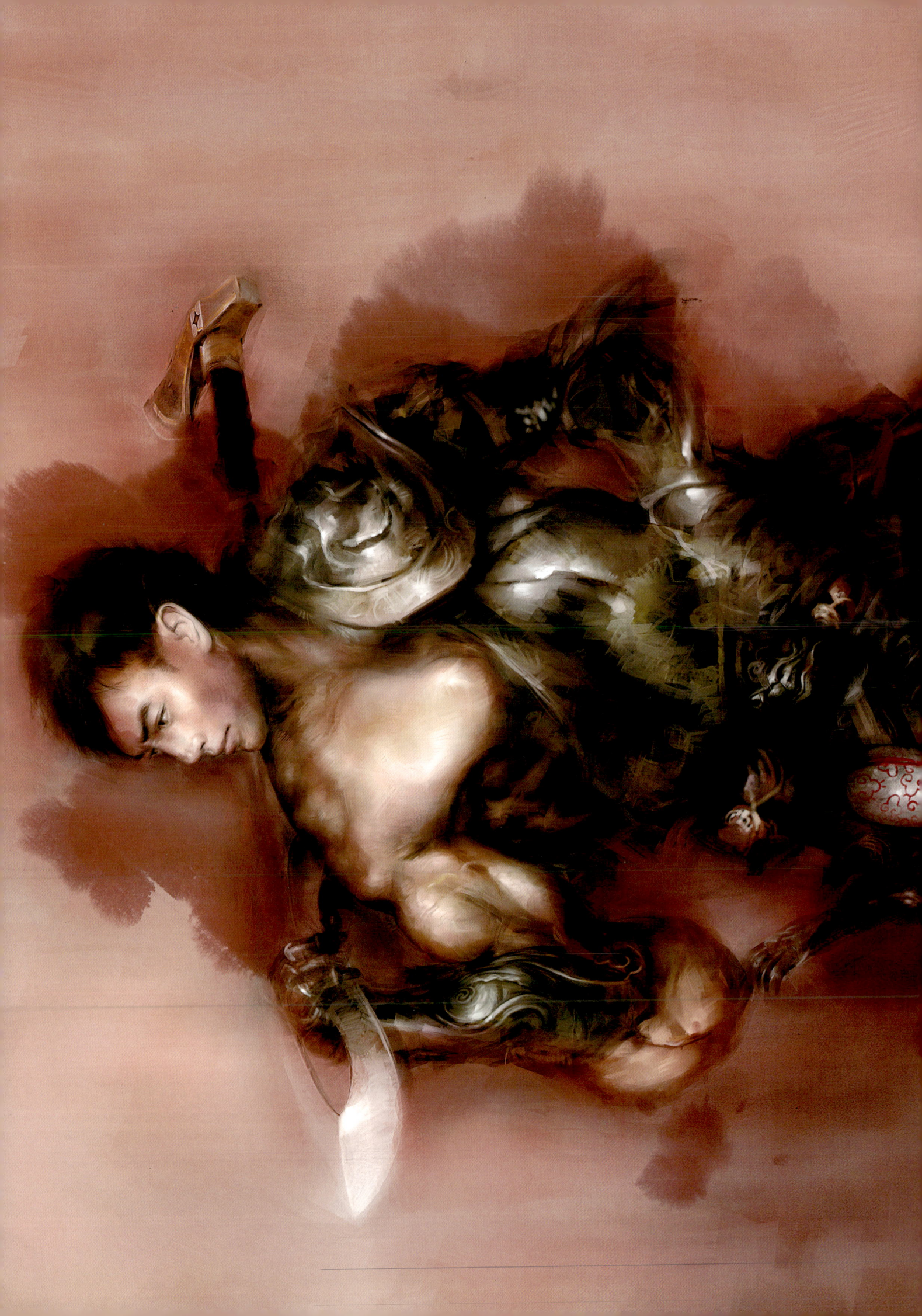

The first son of Tie Muzhen: Wu Shu
Photoshop, Painter
Weng Ziyang, CHINA

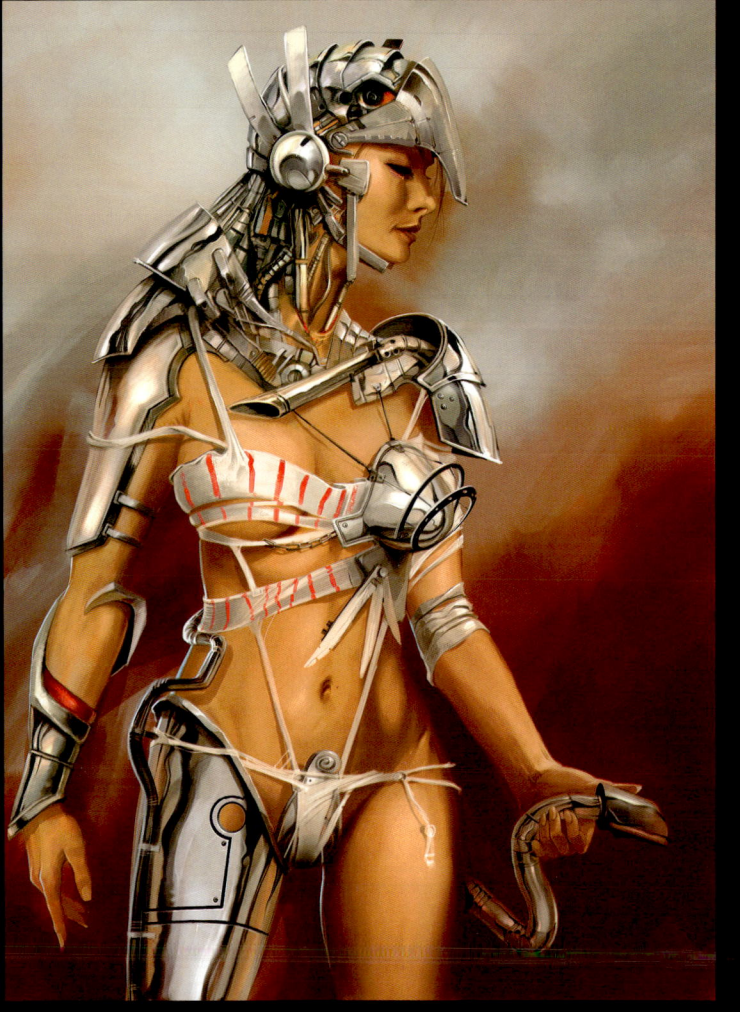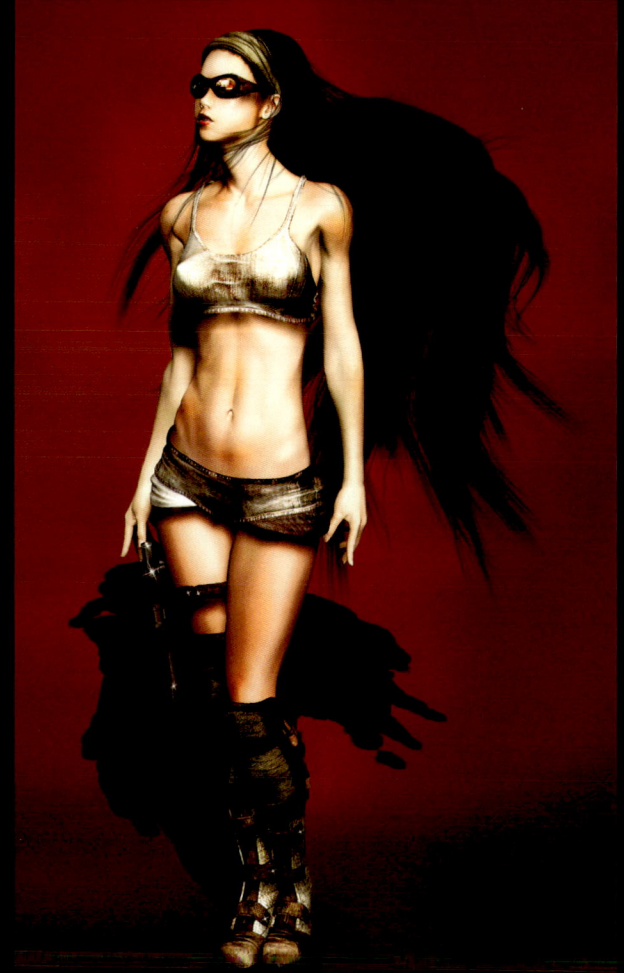

Evolution
Photoshop, Painter
Simon Robert, ROMANIA
[far left]

Trigger Hippy
Poser, Photoshop
Nikki Kirk, GREAT BRITAIN
[left]

The Knife!
Photoshop
Arne S. Reismueller,
GERMANY
[right]

Who's next?
Photoshop, Painter
Steve Argyle, USA
[left]

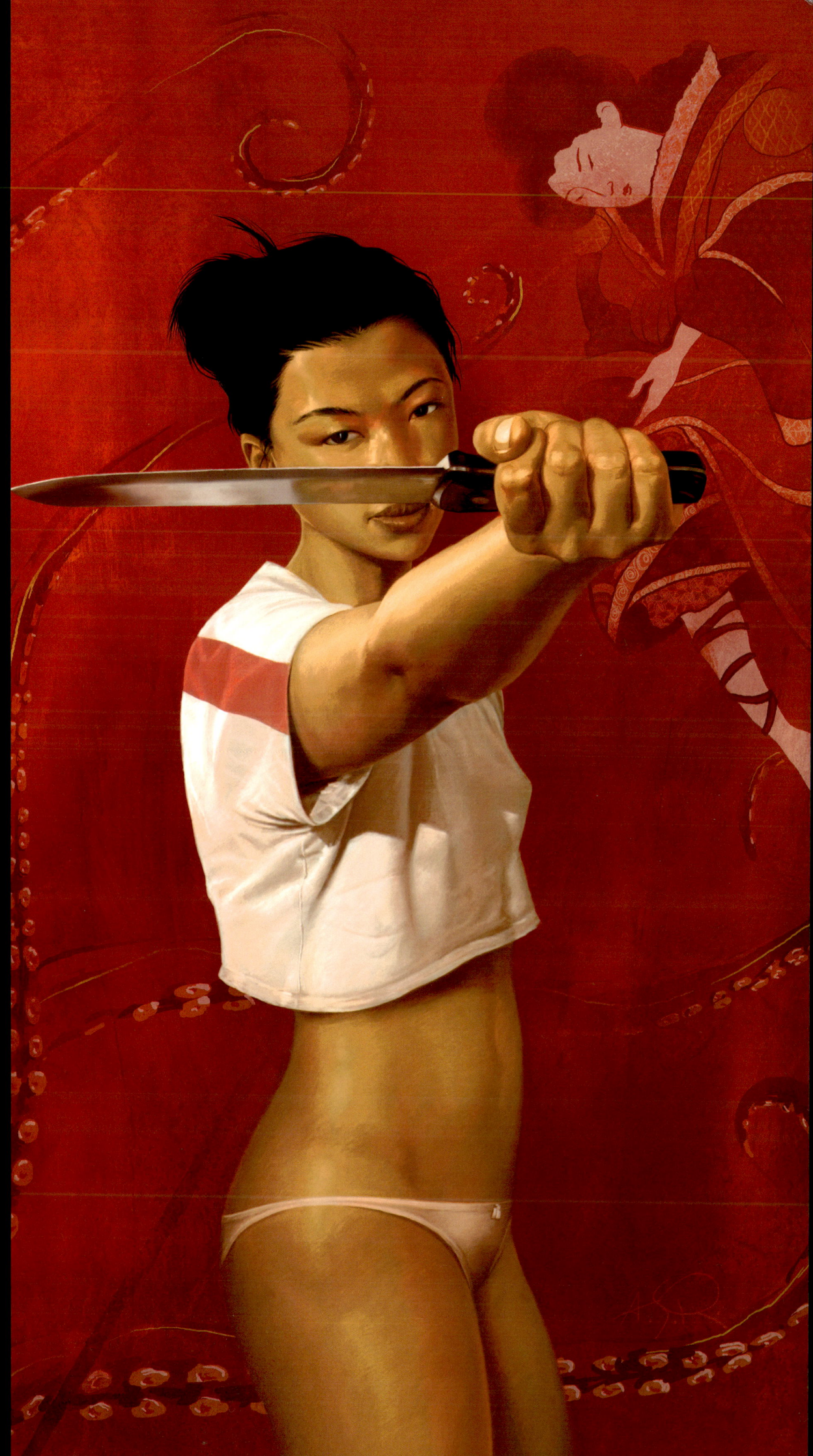

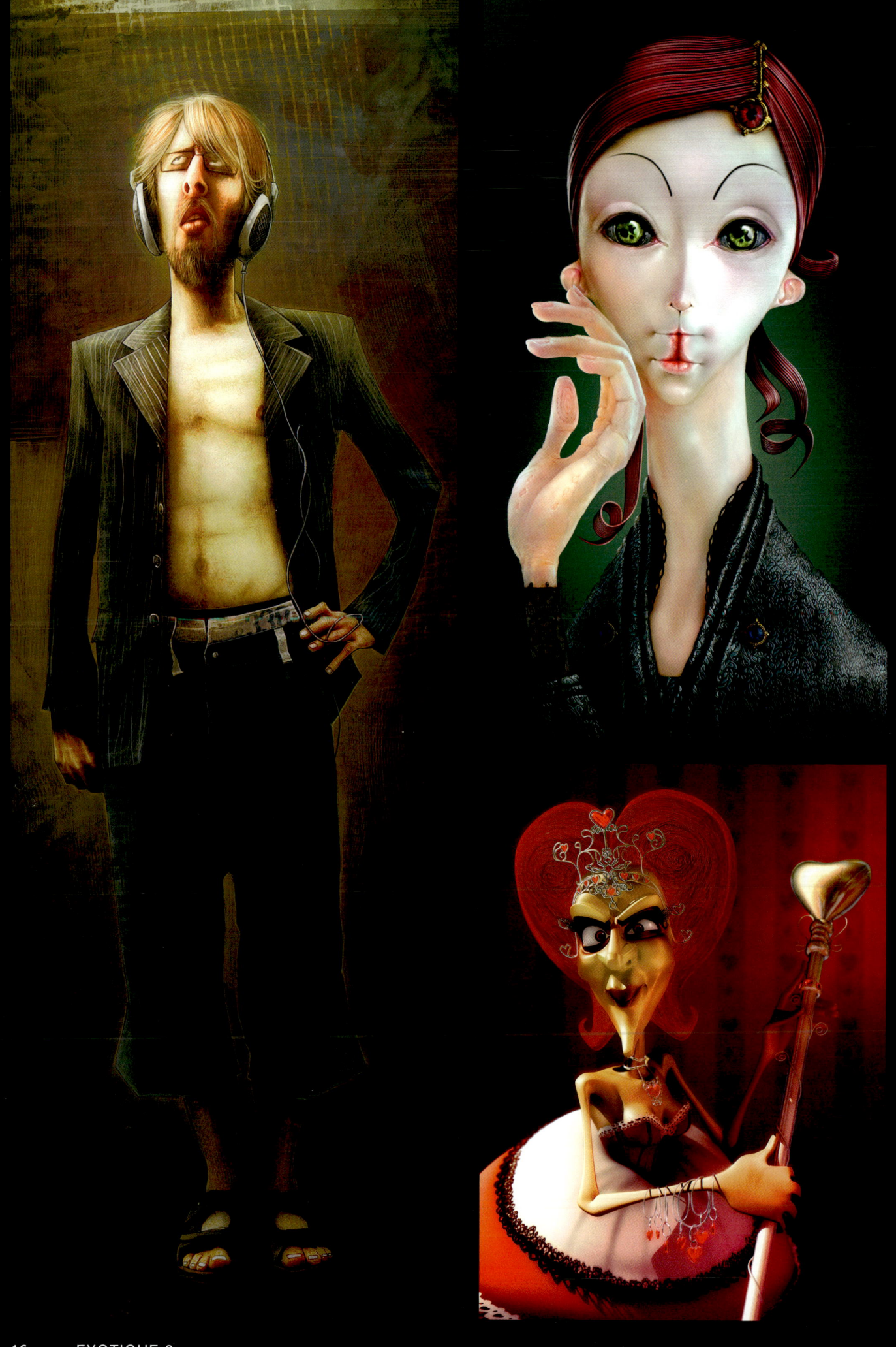

Ladies, I'm ready to rumble
Photoshop
Loïc Zimmermann, FRANCE
[far left]

Nene
Photoshop
Von Caberte, PHILIPPINES
[left]

Anneta
3ds Max, mental ray,
Photoshop
Jonathan Simard, CANADA
[right]

Queen of Hearts
3ds Max, mental ray,
Photoshop
Juliano Castro, BRAZIL
[left]

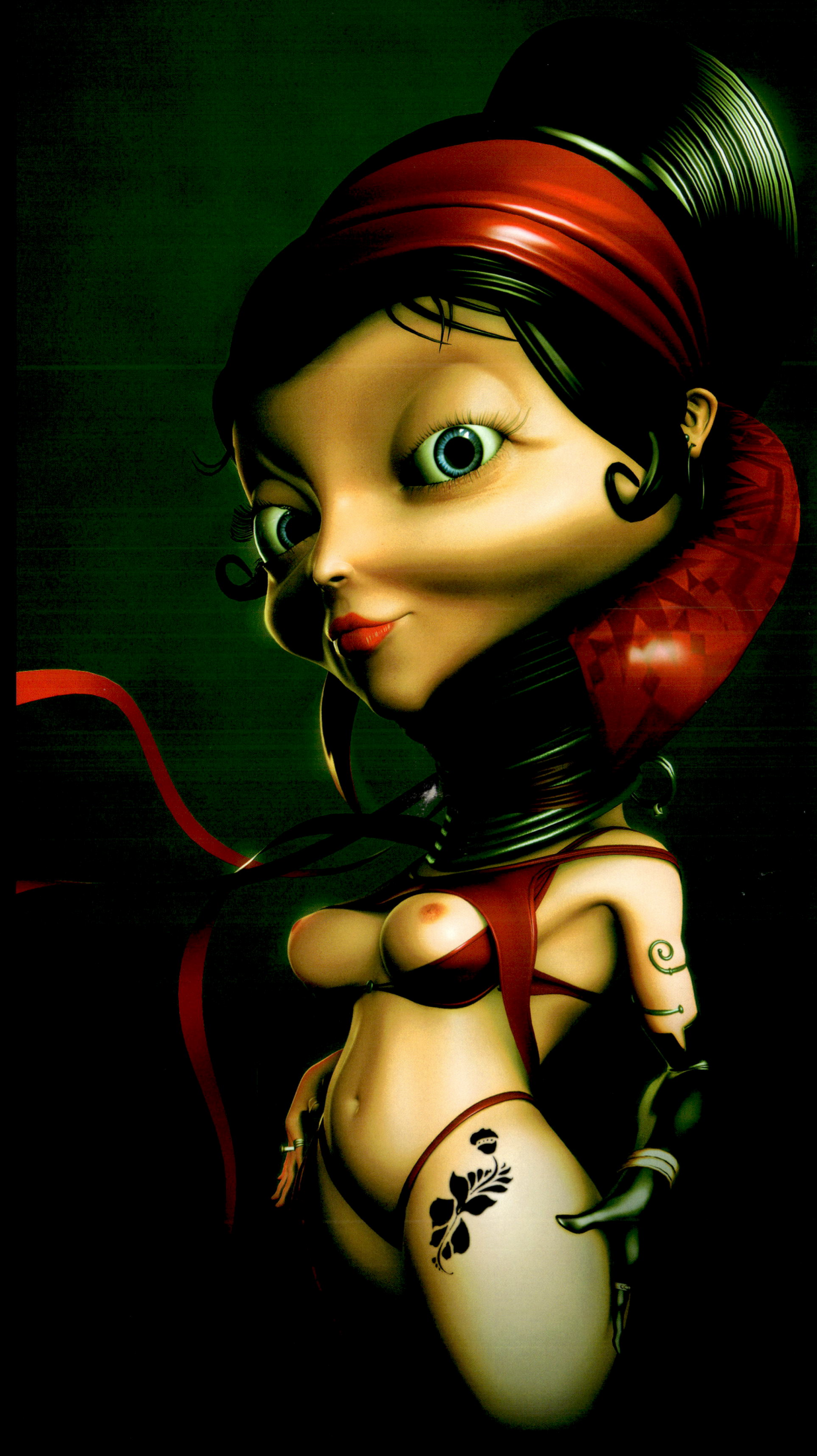

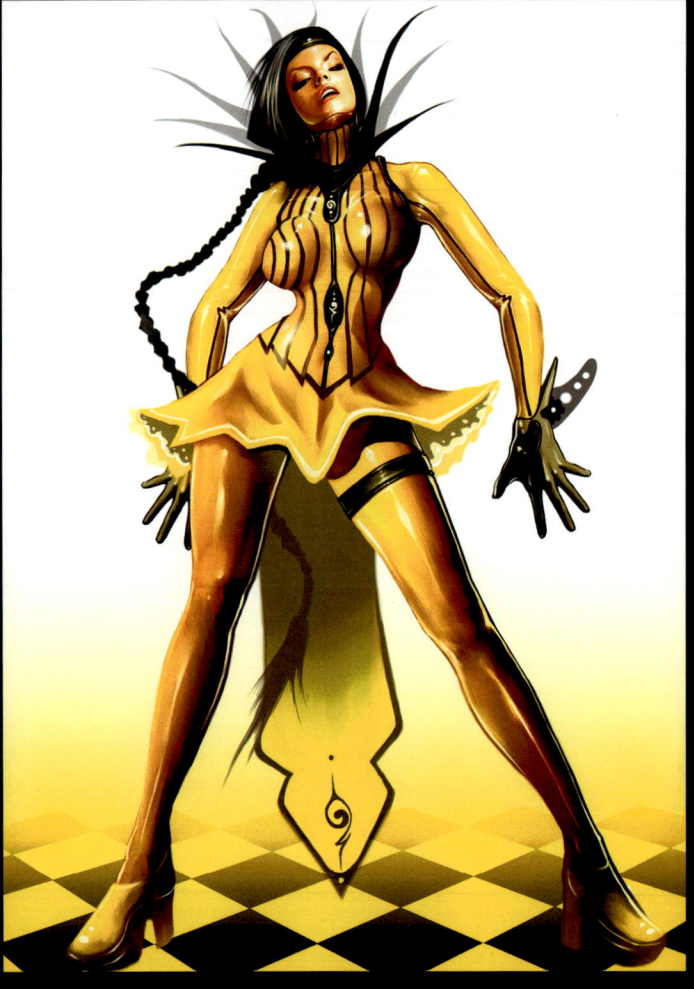
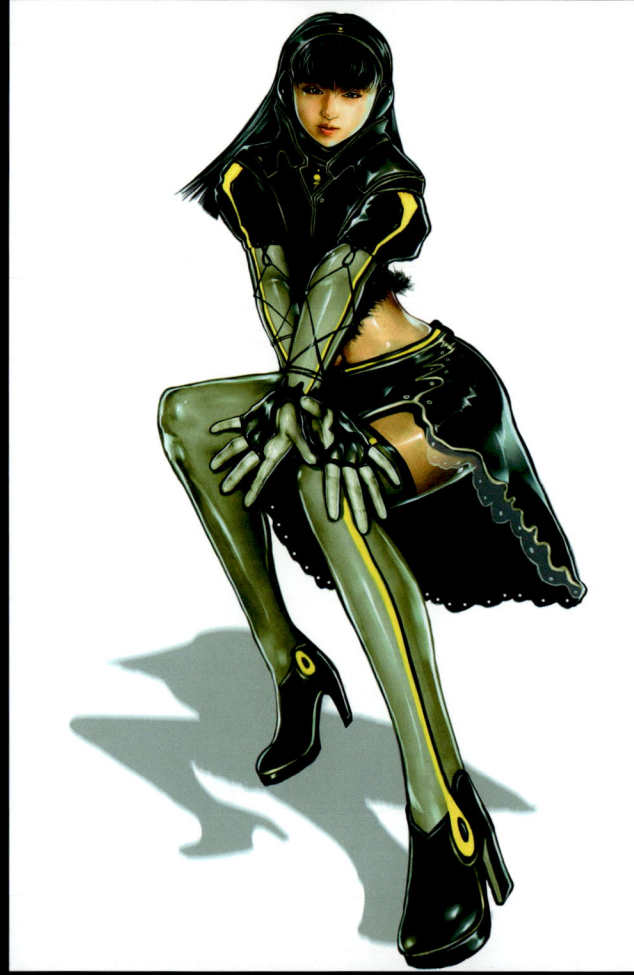
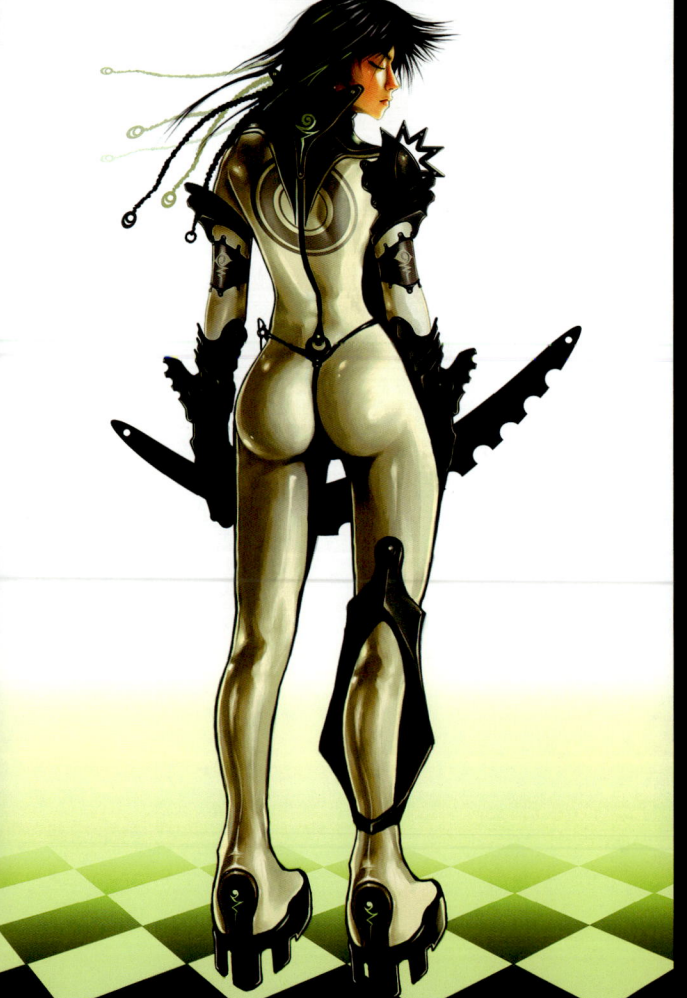

Bubsaba
Photoshop, Painter
Chairat Ketnirattana,
PHILIPPINES
[top left]

Jamjuree
Painter
Chairat Ketnirattana,
PHILIPPINES
[above]

Jenjira
Painter, Photoshop
Chairat Ketnirattana,
PHILIPPINES
[left]

Anachonic Ketnirattana
Painter, Photoshop
Chairat Ketnirattana,
PHILIPPINES
[right]

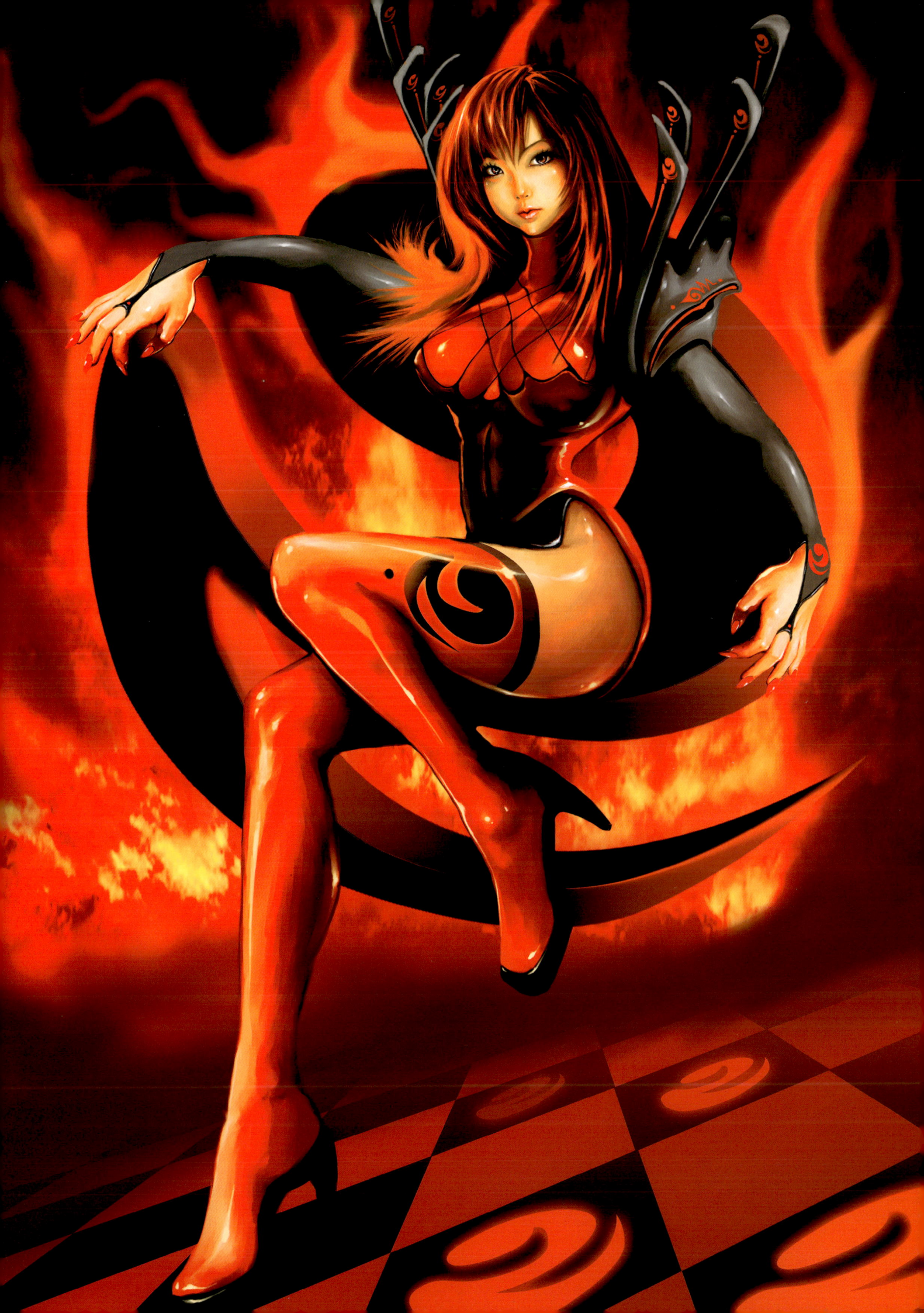

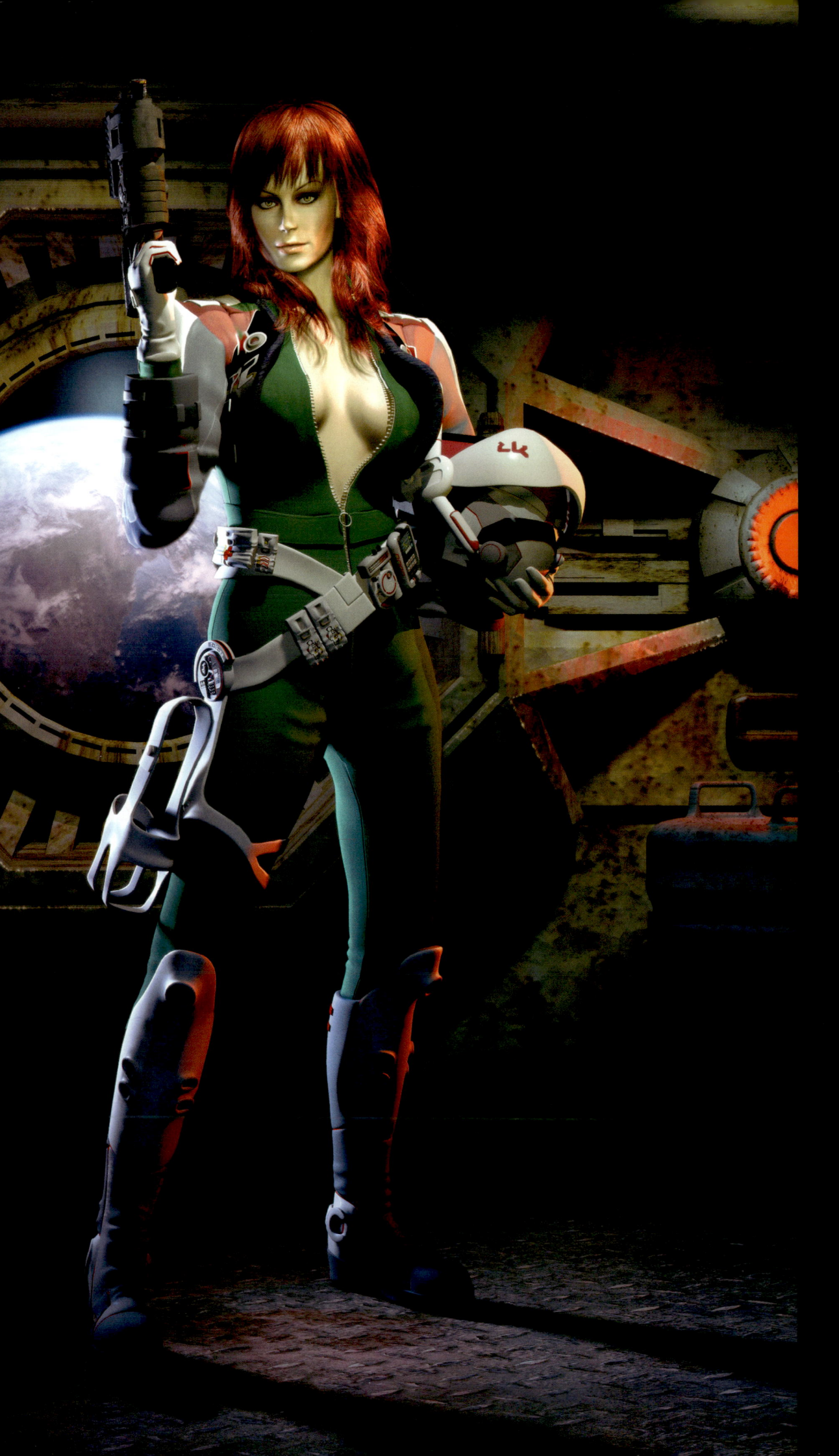

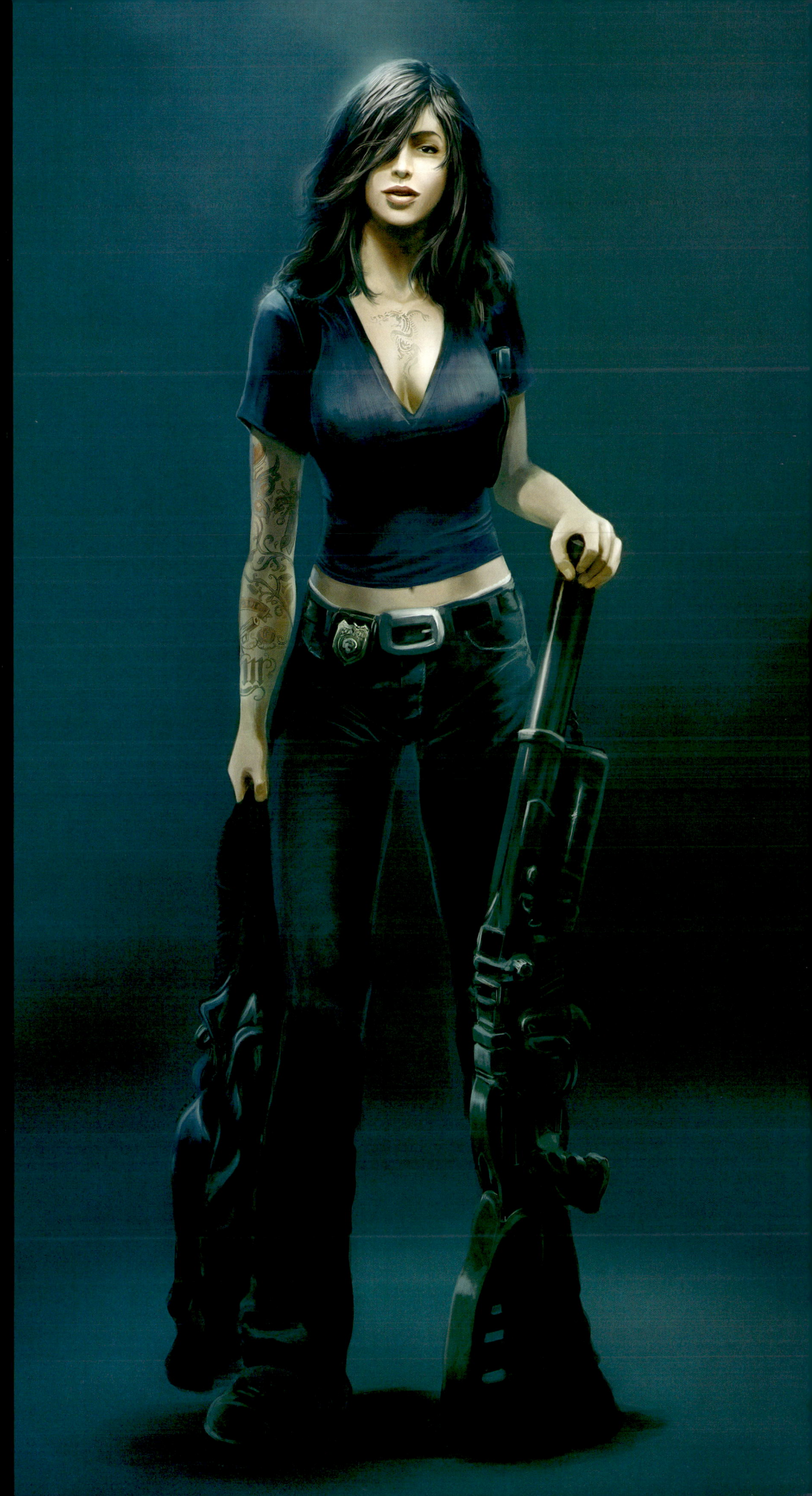

Space vixen
CINEMA 4D, Bryce, Poser
Adam Benton, GREAT BRITAIN
[left]

Cop of the year
Photoshop
Client: Life is Short magazine
Giuliano Brocani, Keller Adv,
ITALY
[right]

Trixie
Photoshop
Art Director: Farzad Varahramyan
Francis Tsai, High Moon Studios, USA

Emperor (Nightingale)
Photoshop
Bruno Werneck, USA

Bai yin
Photoshop
Xiao-chen Fu, CHINA

Character sketch
Painter
Anry Nemo, RUSSIA

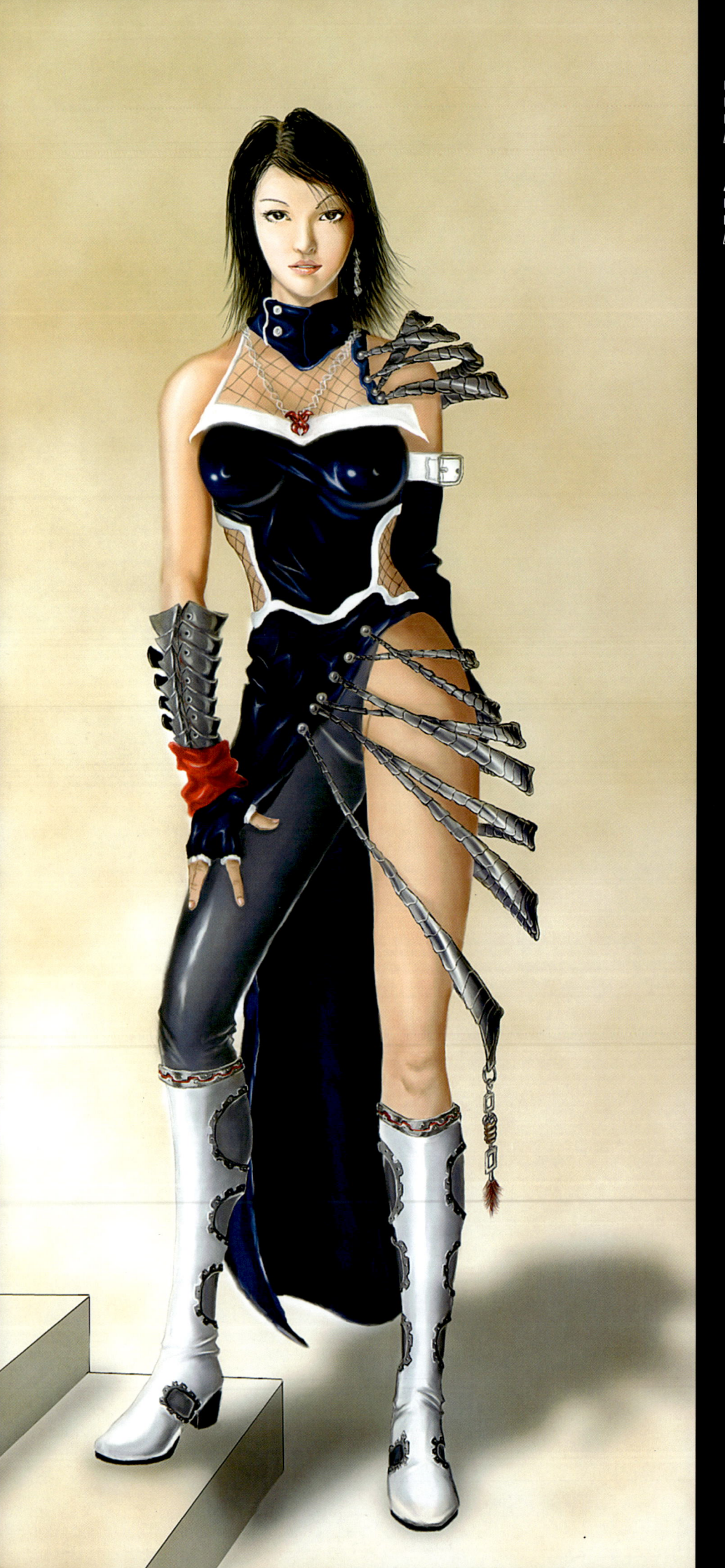

Midnight Blue
Photoshop
Nathalee Inthavong
[left]

Ancient city
Photoshop, Painter
Randy Liu, USA
[right]

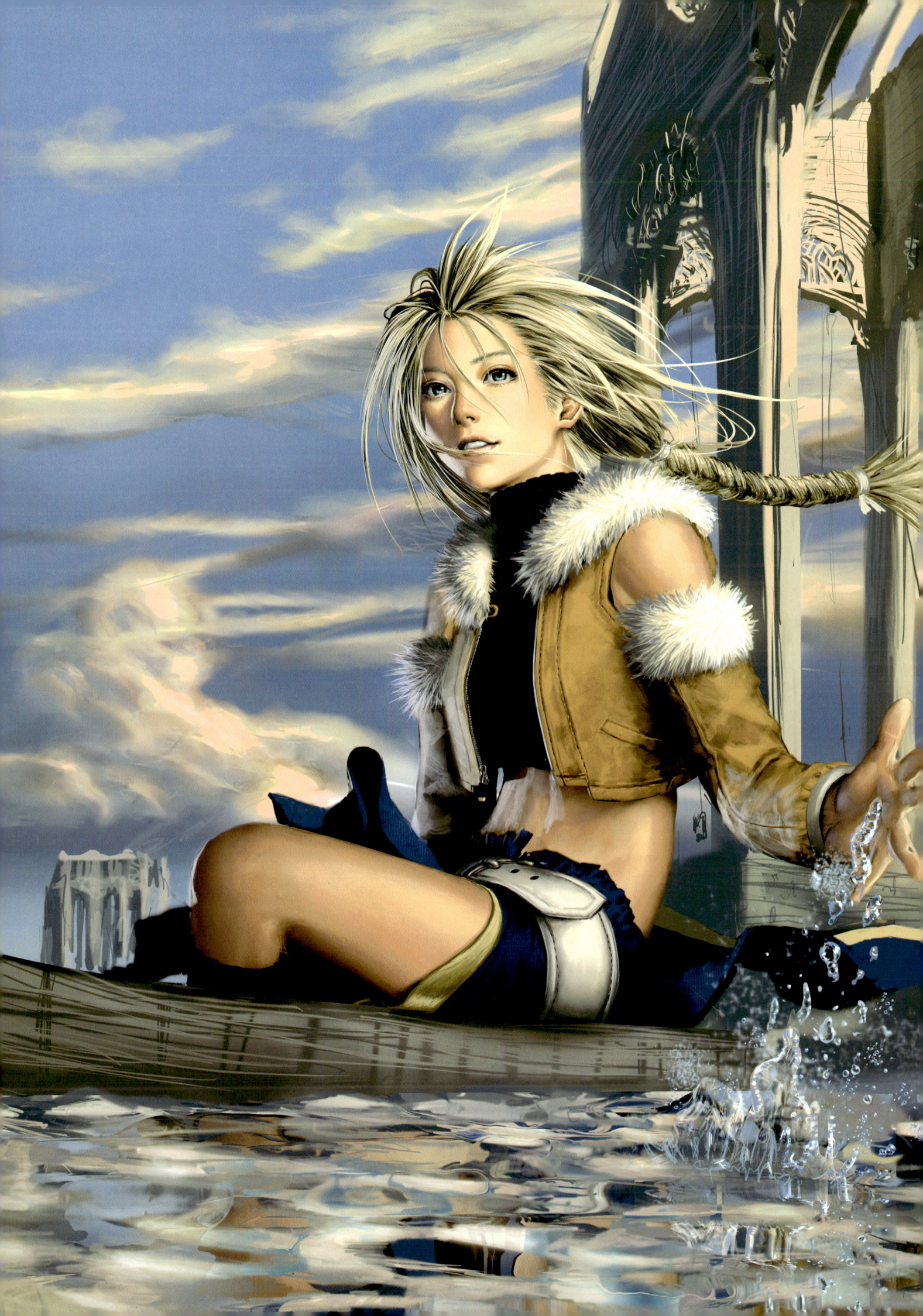

One of the four glorious generals of Yuan dynasty: Bo Erhu
Photoshop, Painter
Weng Ziyang, CHINA
[above]

The greatest king of Yuan dynasty: Tie Muzhen
Photoshop, Painter
Weng Ziyang, CHINA
[above]

Piper Angel #3
Photoshop
Skan Srisuwan, THAILAND
[right]

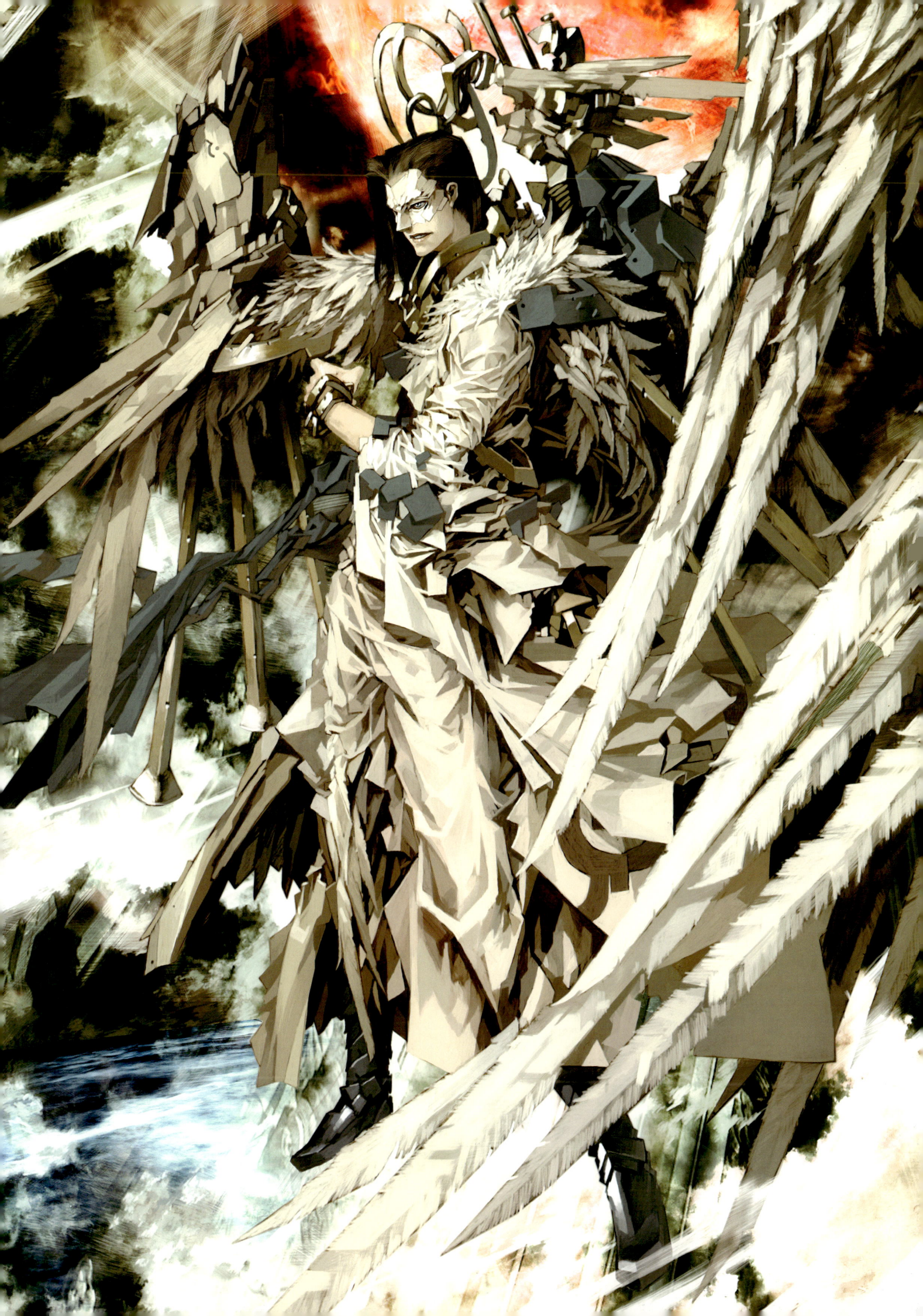

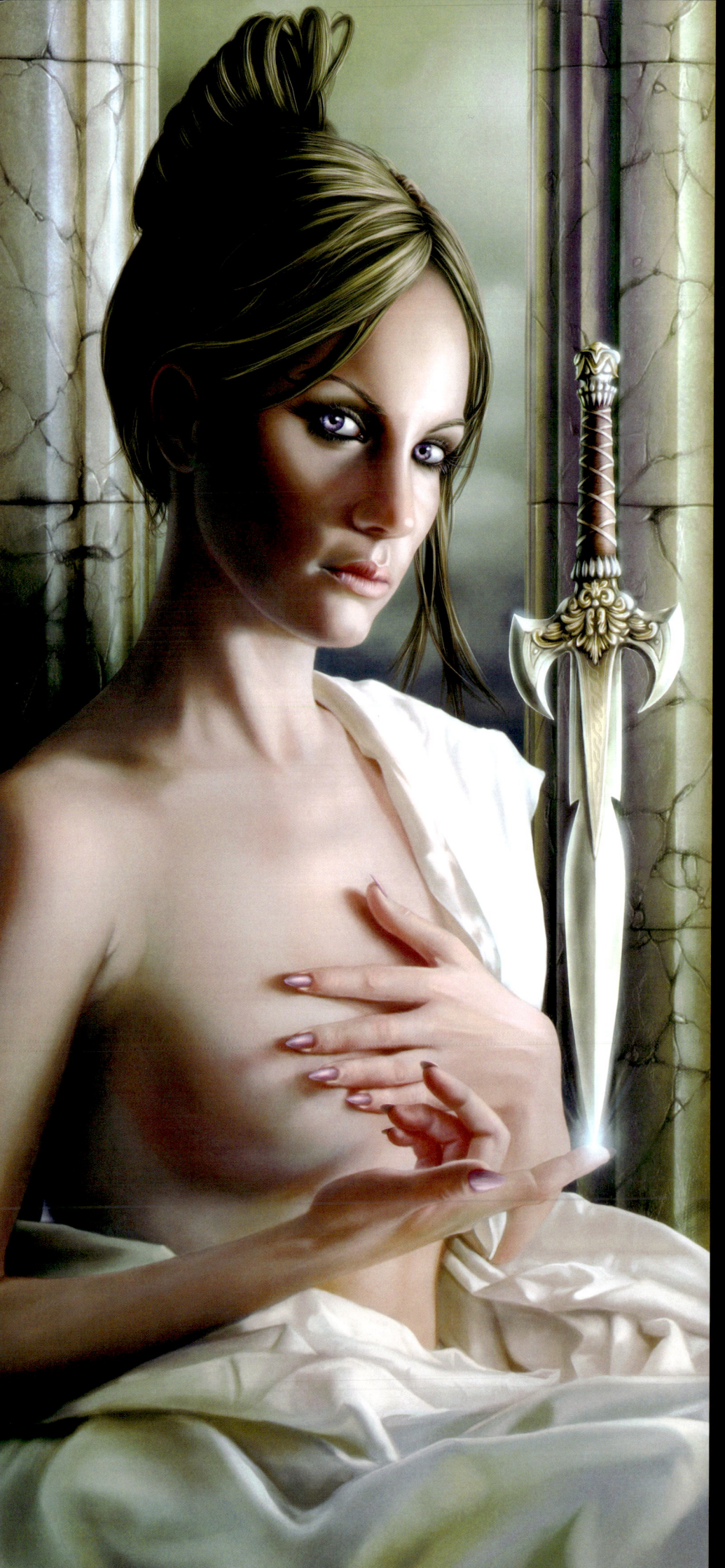

Equilibrium
Photoshop
Henning Ludvigsen, NORWAY
[left]

Europa
3ds Max, VRay, Photoshop
Soa Lee, KOREA
[right]

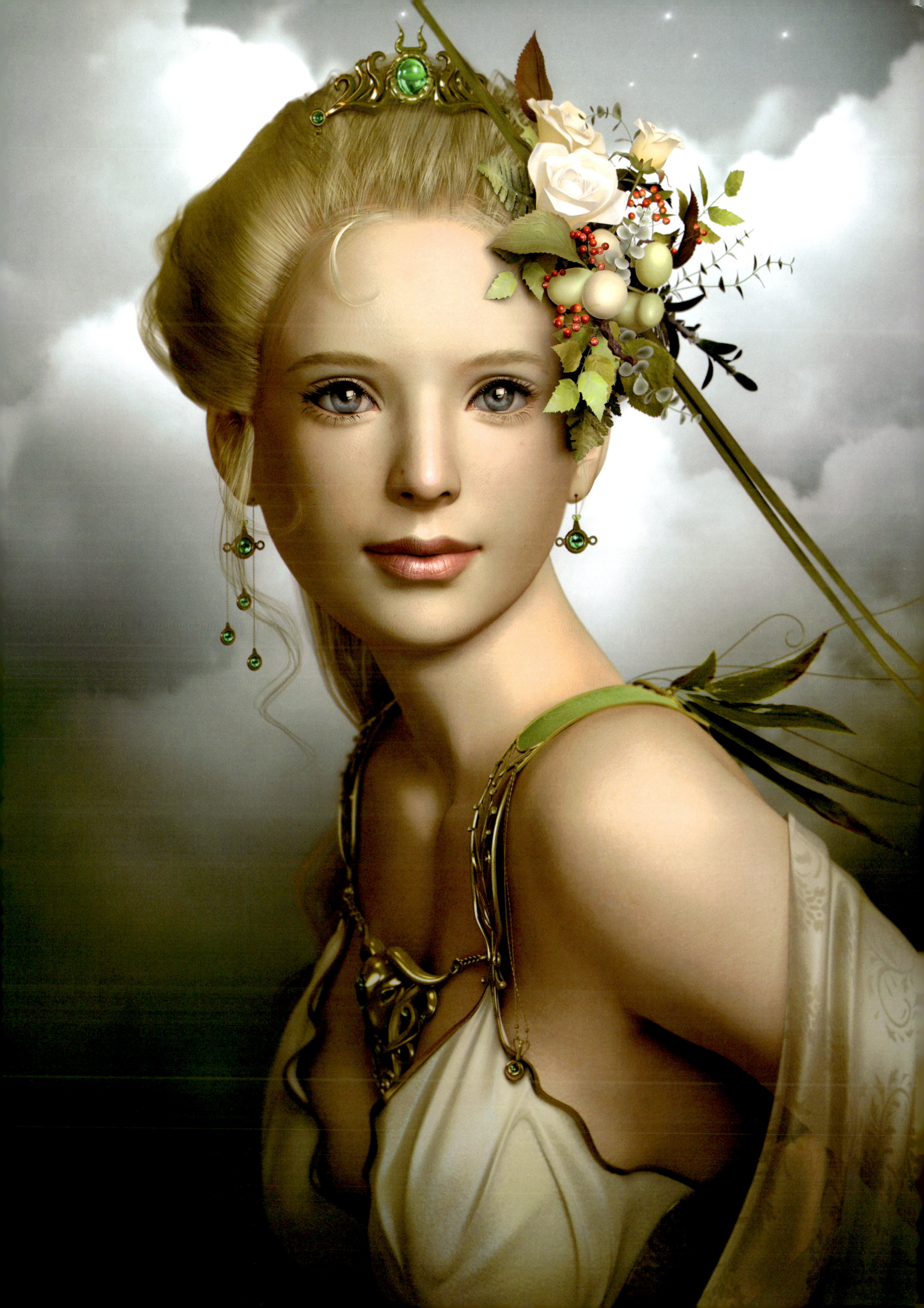

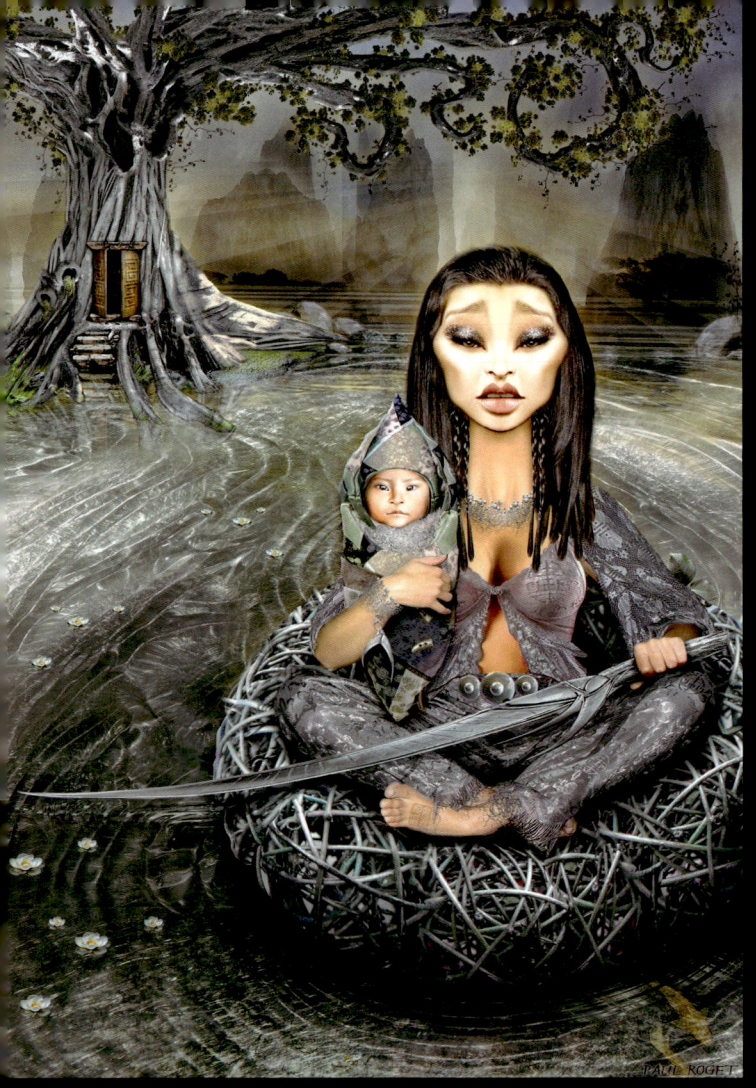
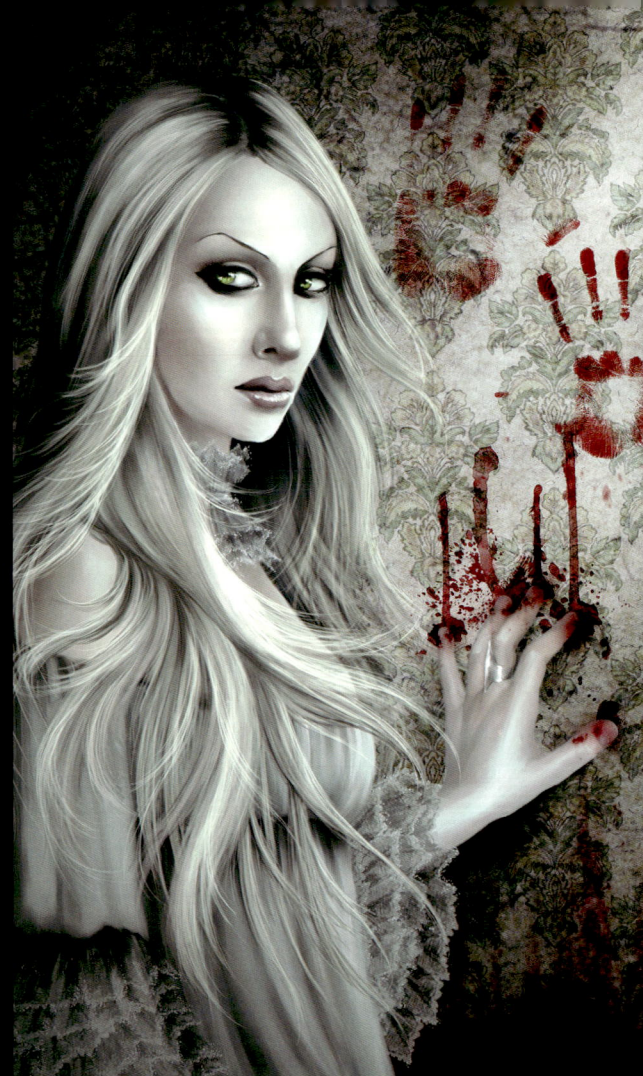
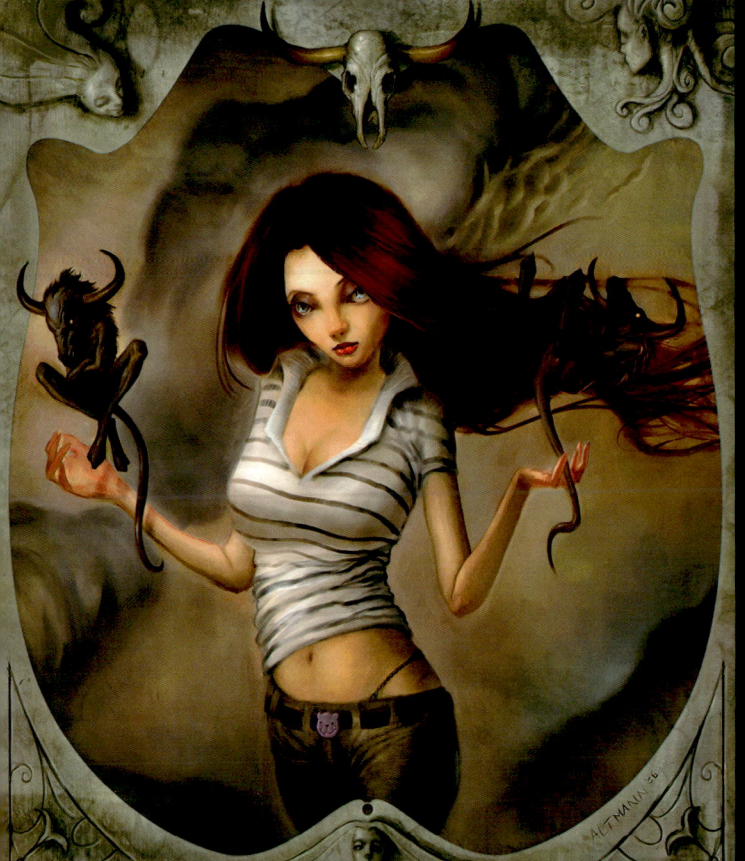

Hinayana
Photoshop
Paul Roget, AUSTRALIA
[top left]

Sometimes they leave fingerprints
Photoshop, Painter
Gracjana Zielinska, POLAND
[above]

Handspells
Painter, Illustrator, Photoshop
Scott Altmann, USA
[left]

Arachnid
Photoshop
Sarah Decker, USA
[right]

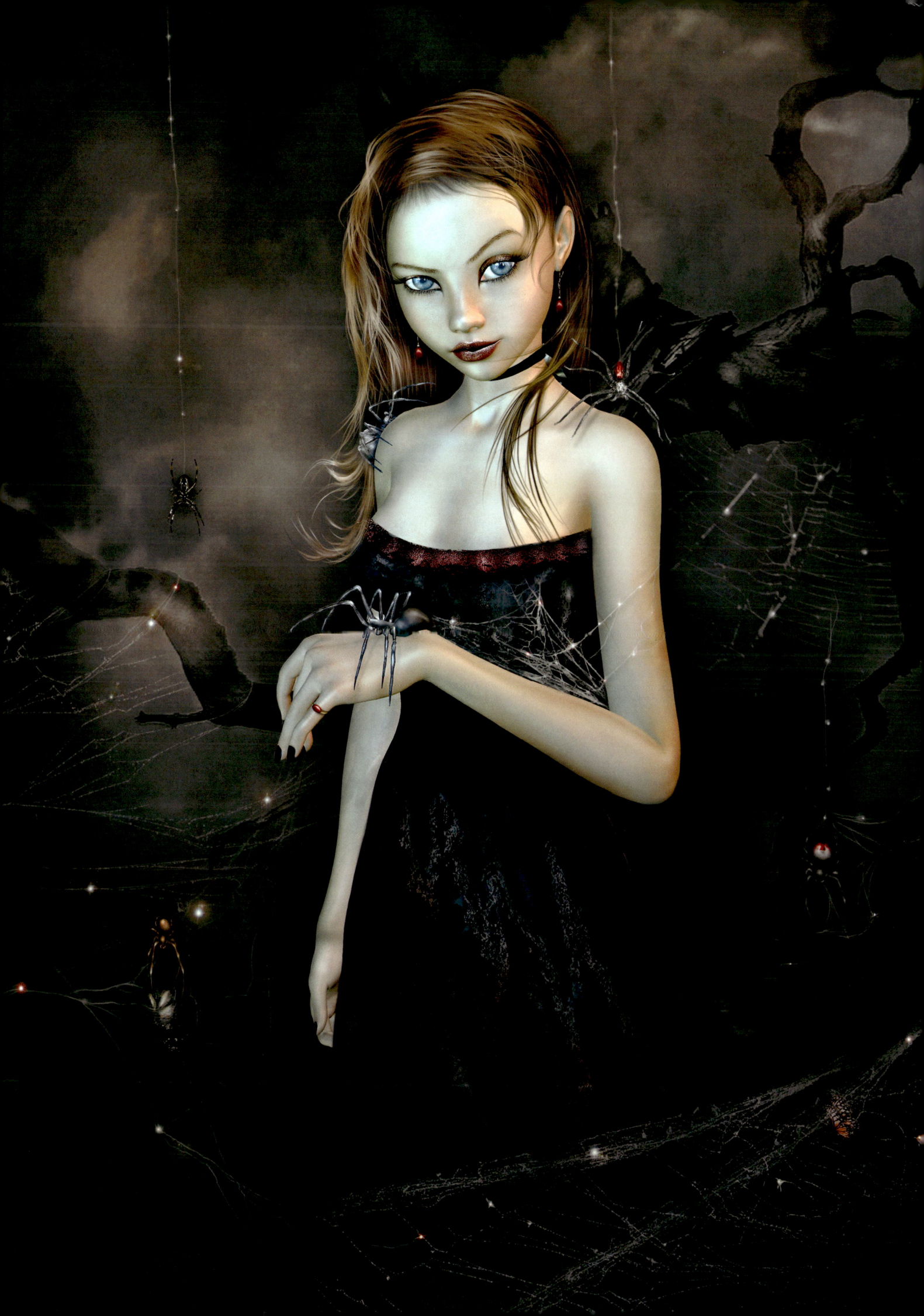

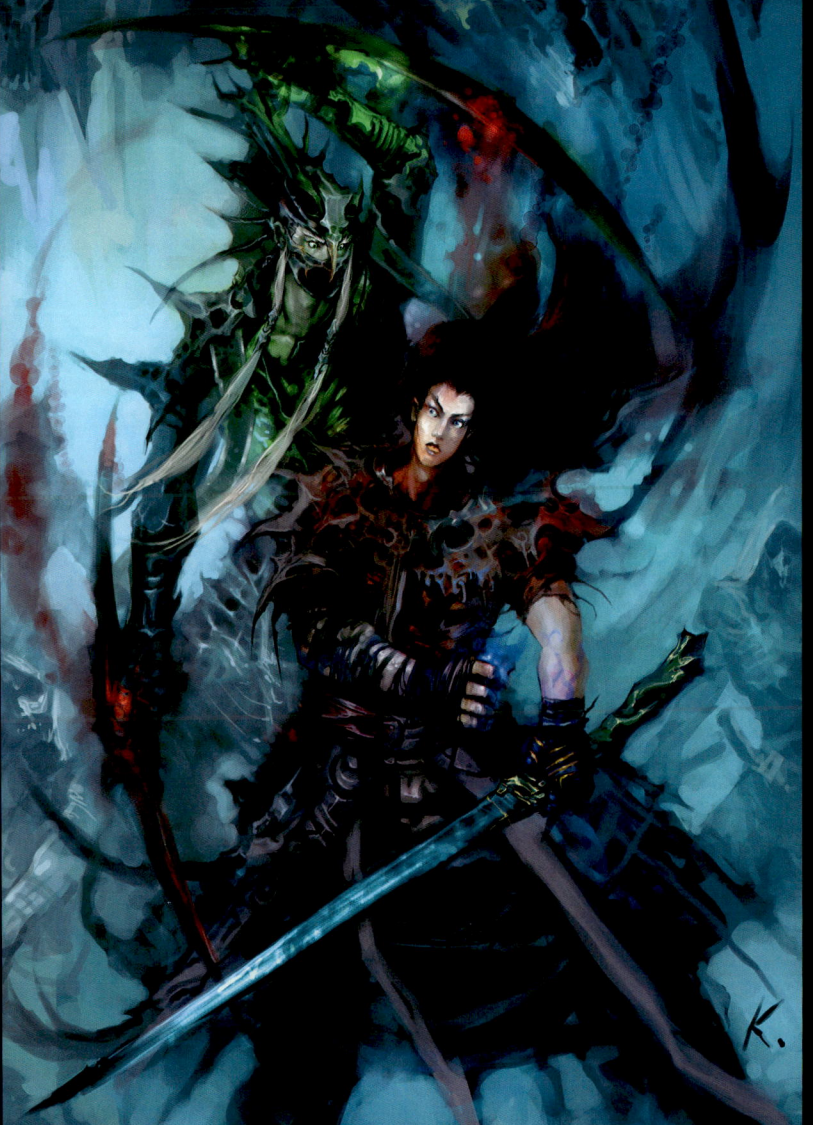

Neida
Photoshop, Painter
Tomasz Jedruszek, POLAND
[above]

Assassination
Photoshop
Xiao-chen Fu, CHINA
[left]

Cat
Photoshop
Leung Chun Wan, CHINA
[right]

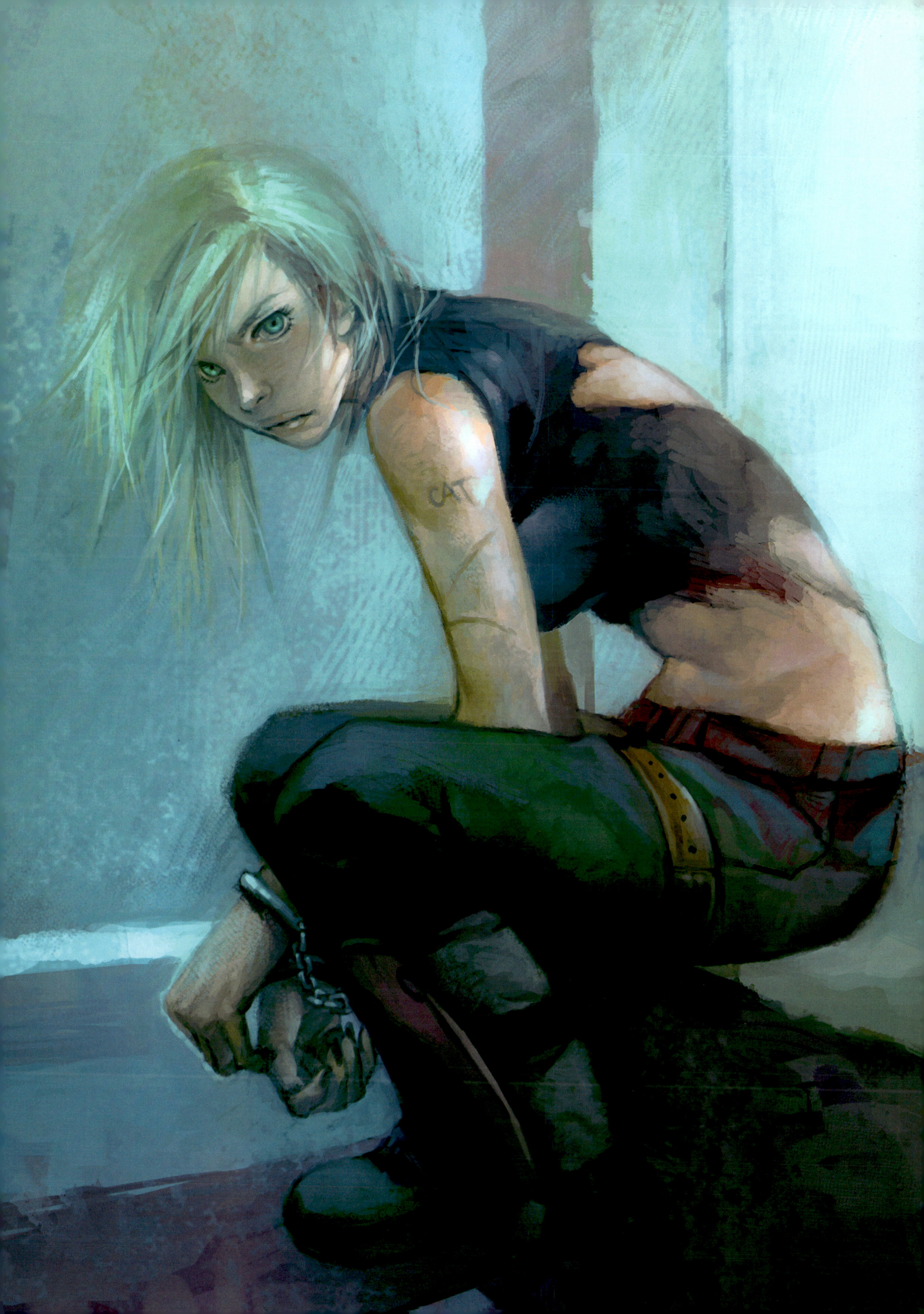

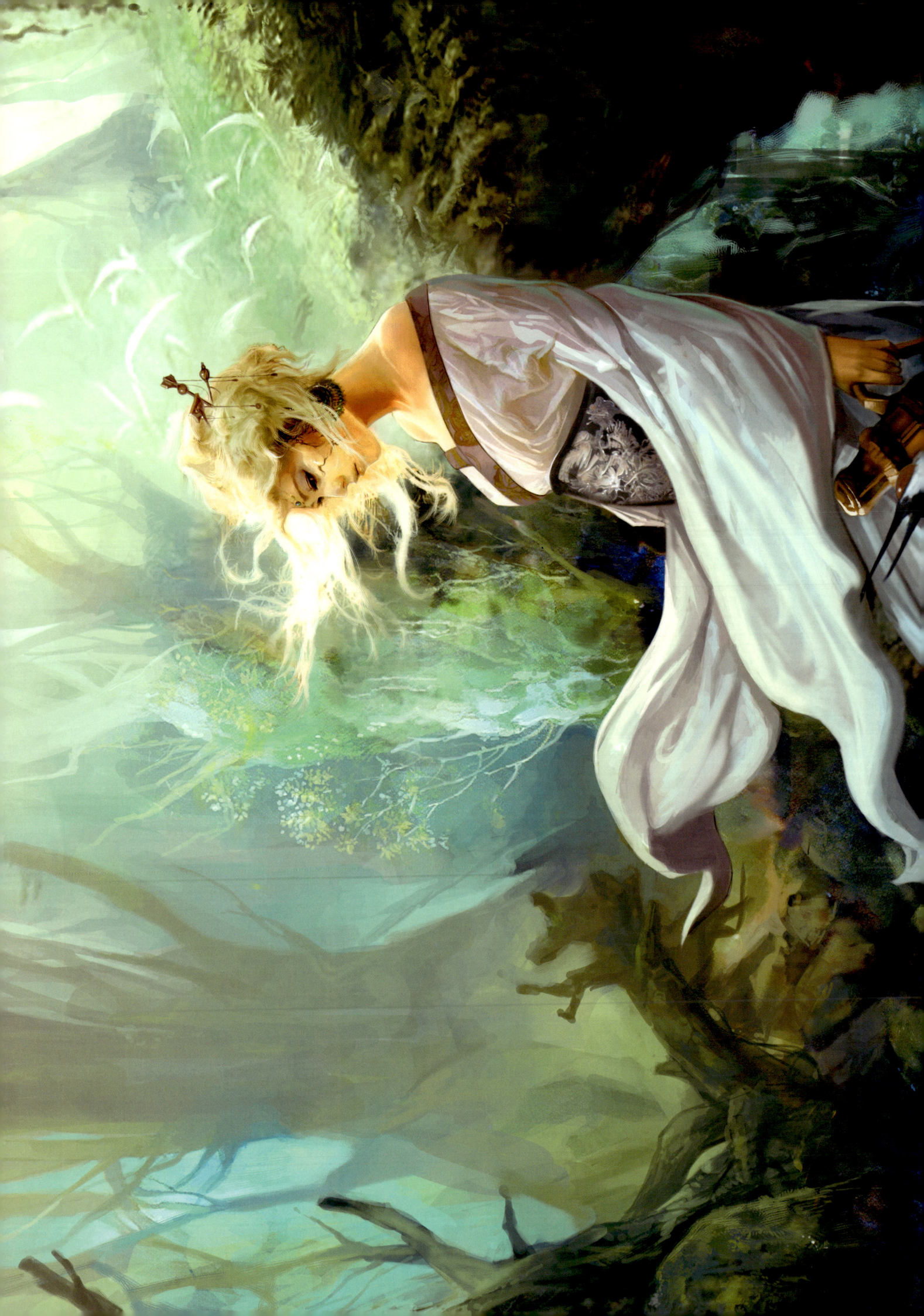

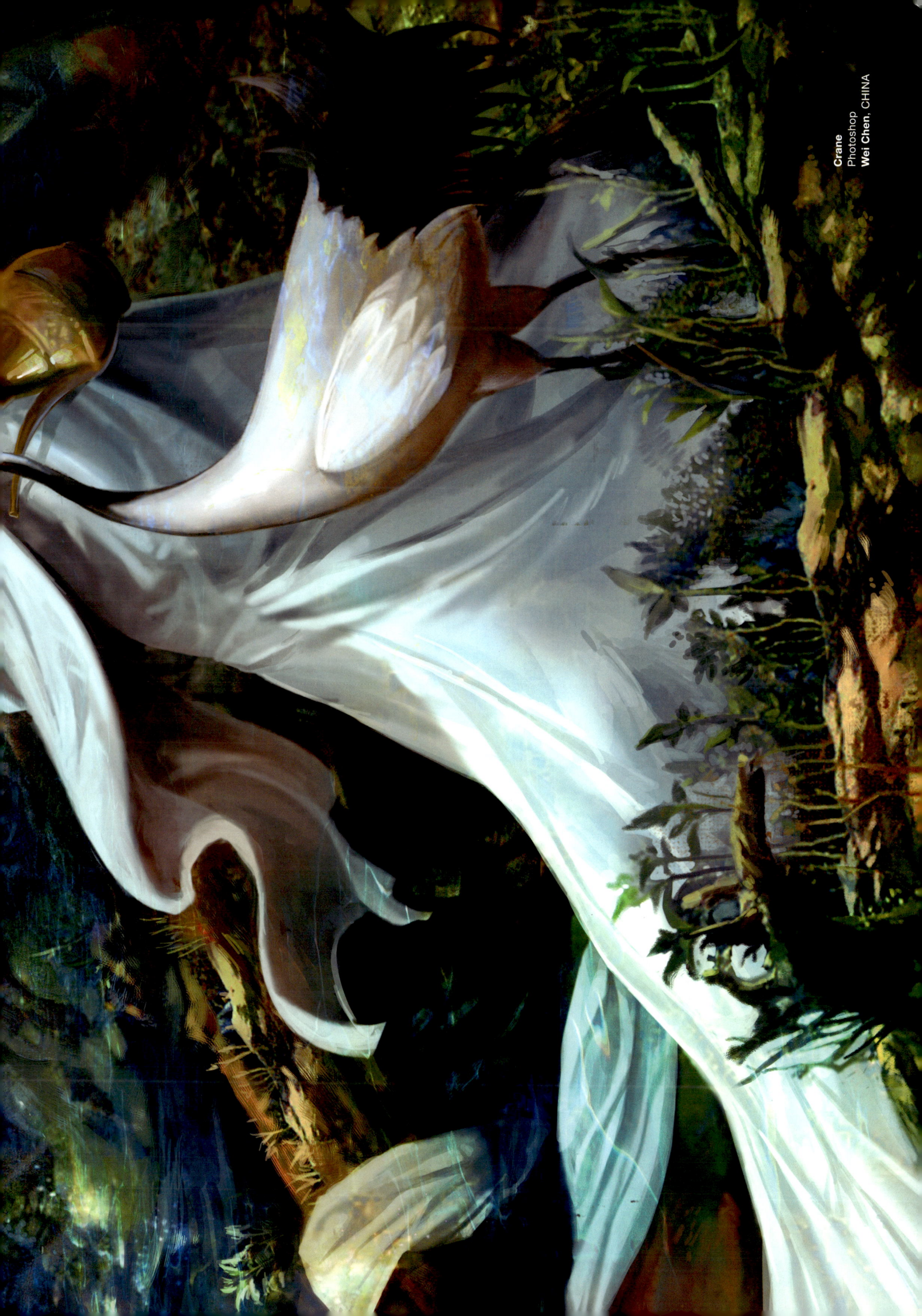

Crane
Photoshop
Wei Chen, CHINA

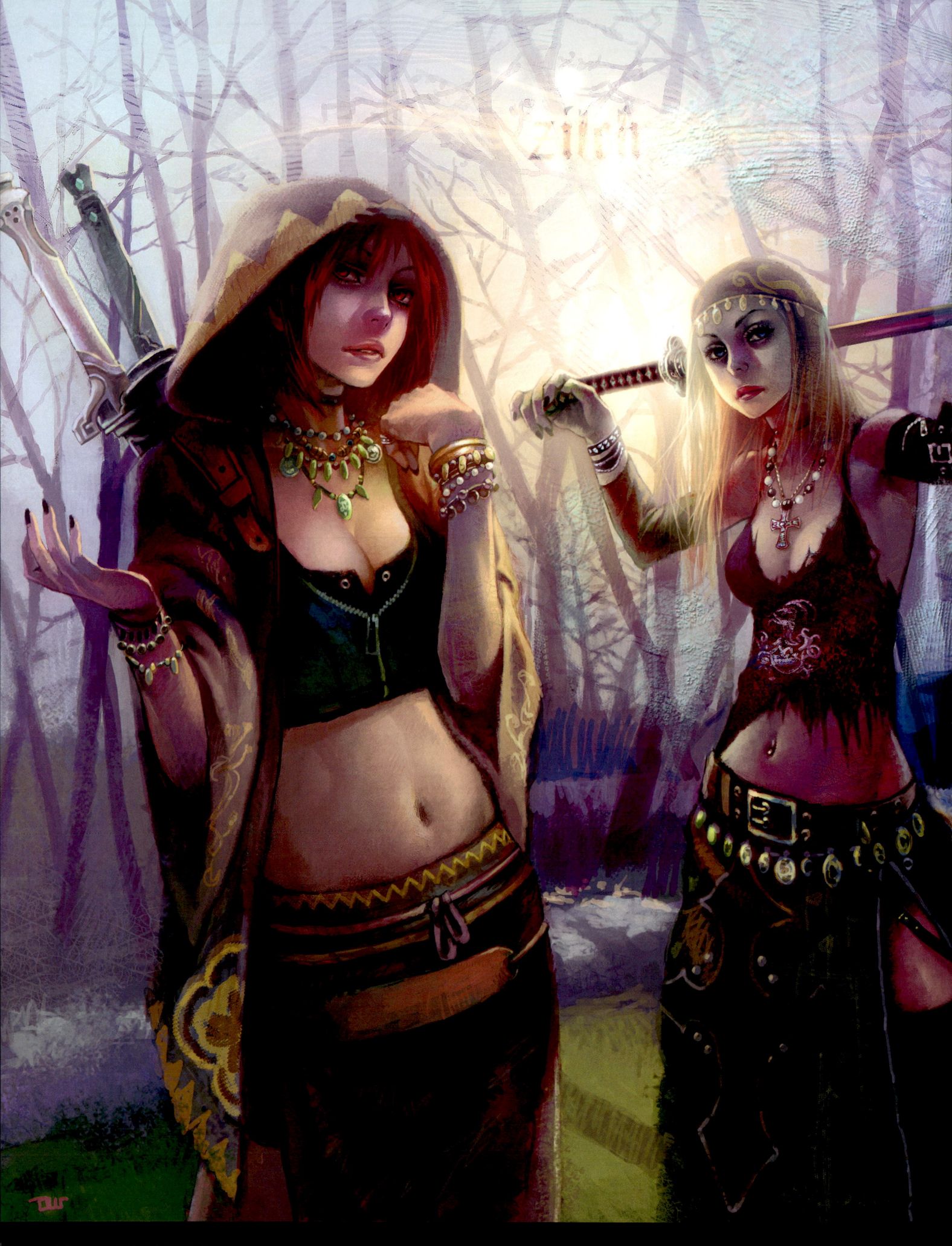

North sky 2
Photoshop
Client: Masanao Amano, ASUKASHINSHA Co.
Leung Chun Wan, CHINA
[far left]

Xiltali
Painter
Roberto Campus, USA
[left]

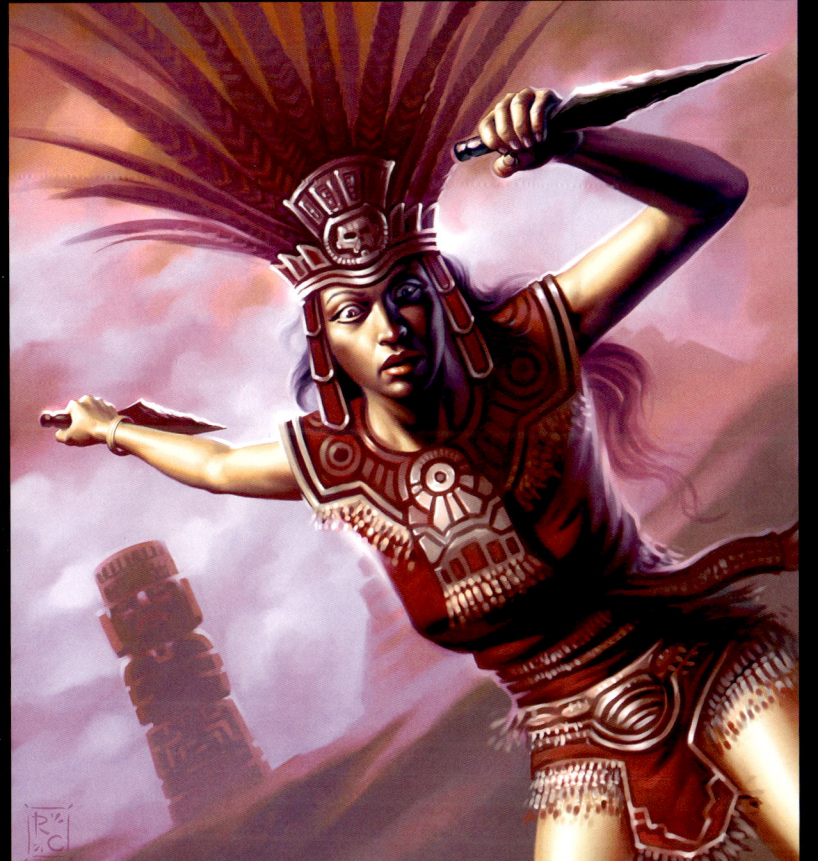

Seductive Intent
Photoshop
Client: DM Bolverk
George Patsouras, USA
[left]

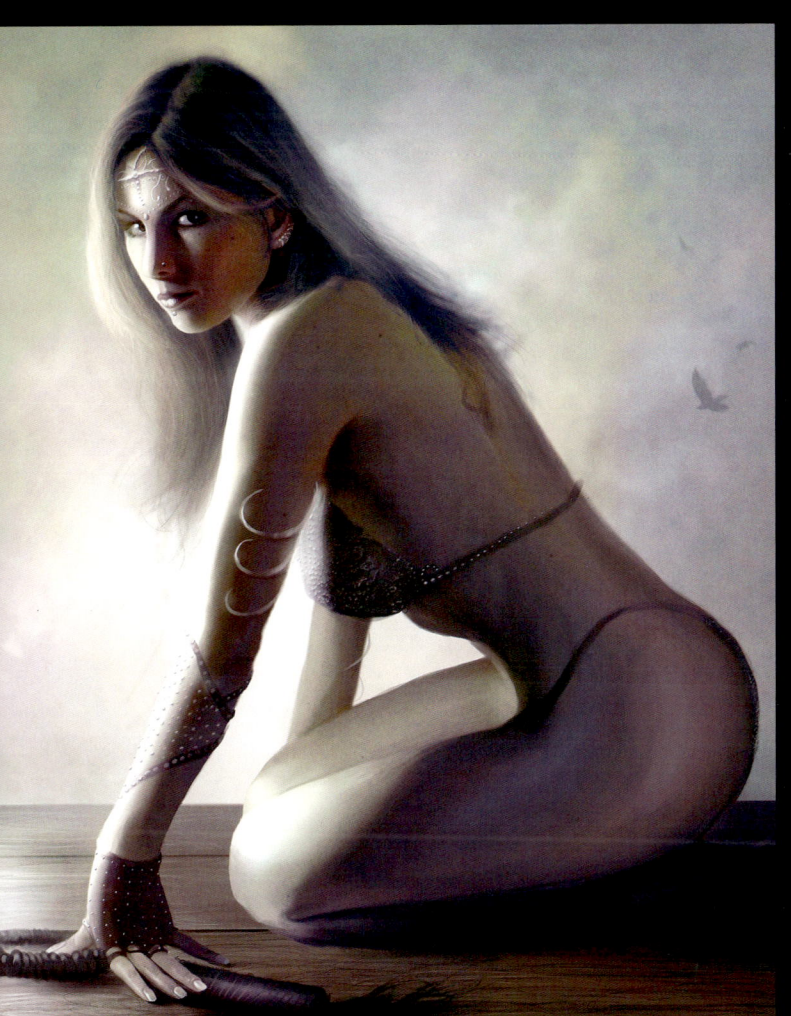

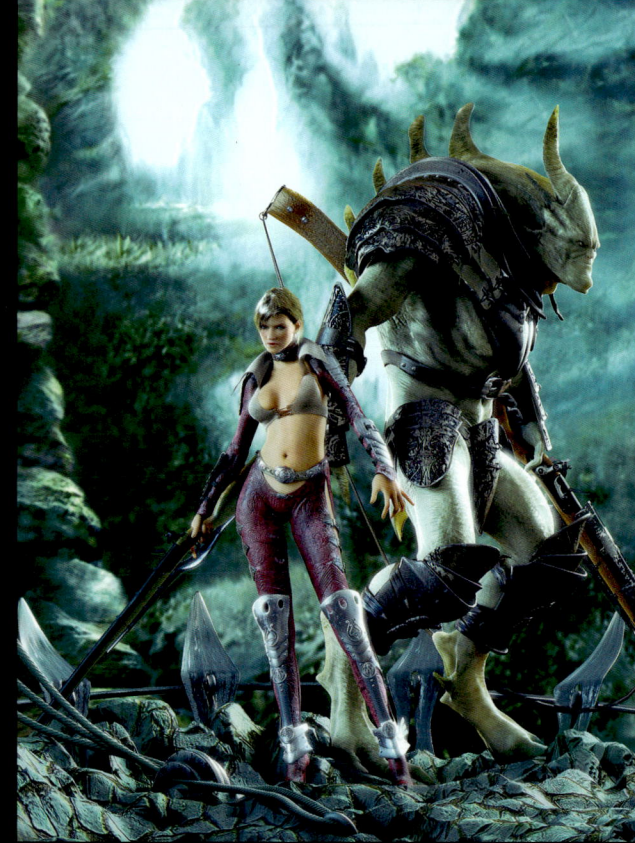
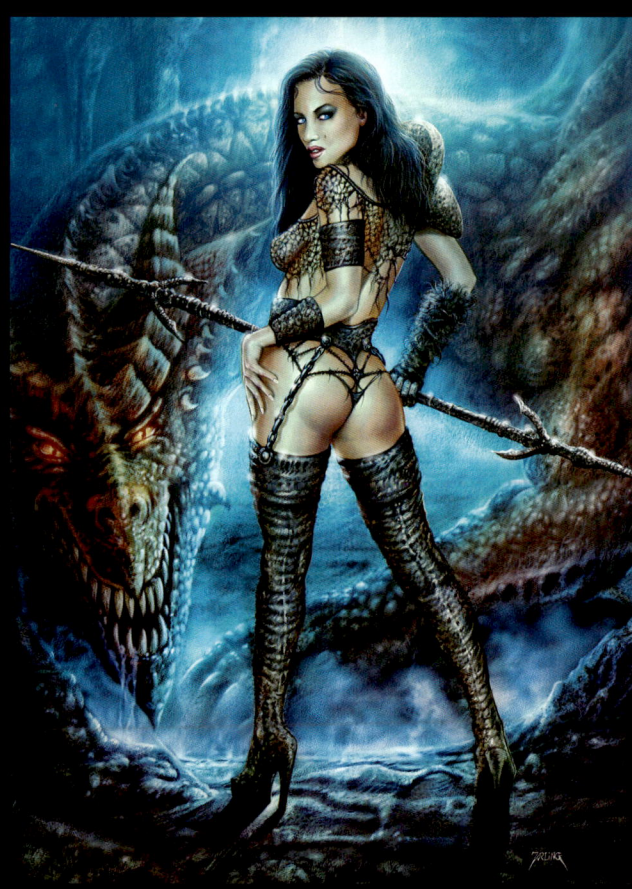

Sea Dancers - Water
Photoshop
Diane Özdamar, FRANCE
[above]

Treasure hunter, Mina & Gaspar
3ds Max, ZBrush, Photoshop
Nguyen Antony, FRANCE
[top right]

Amazon and Dragon
Painter, Photoshop
Uwe Jarling, GERMANY
[above]

Lord of Nightmares
Photoshop
Diane Özdamar, FRANCE
[right]

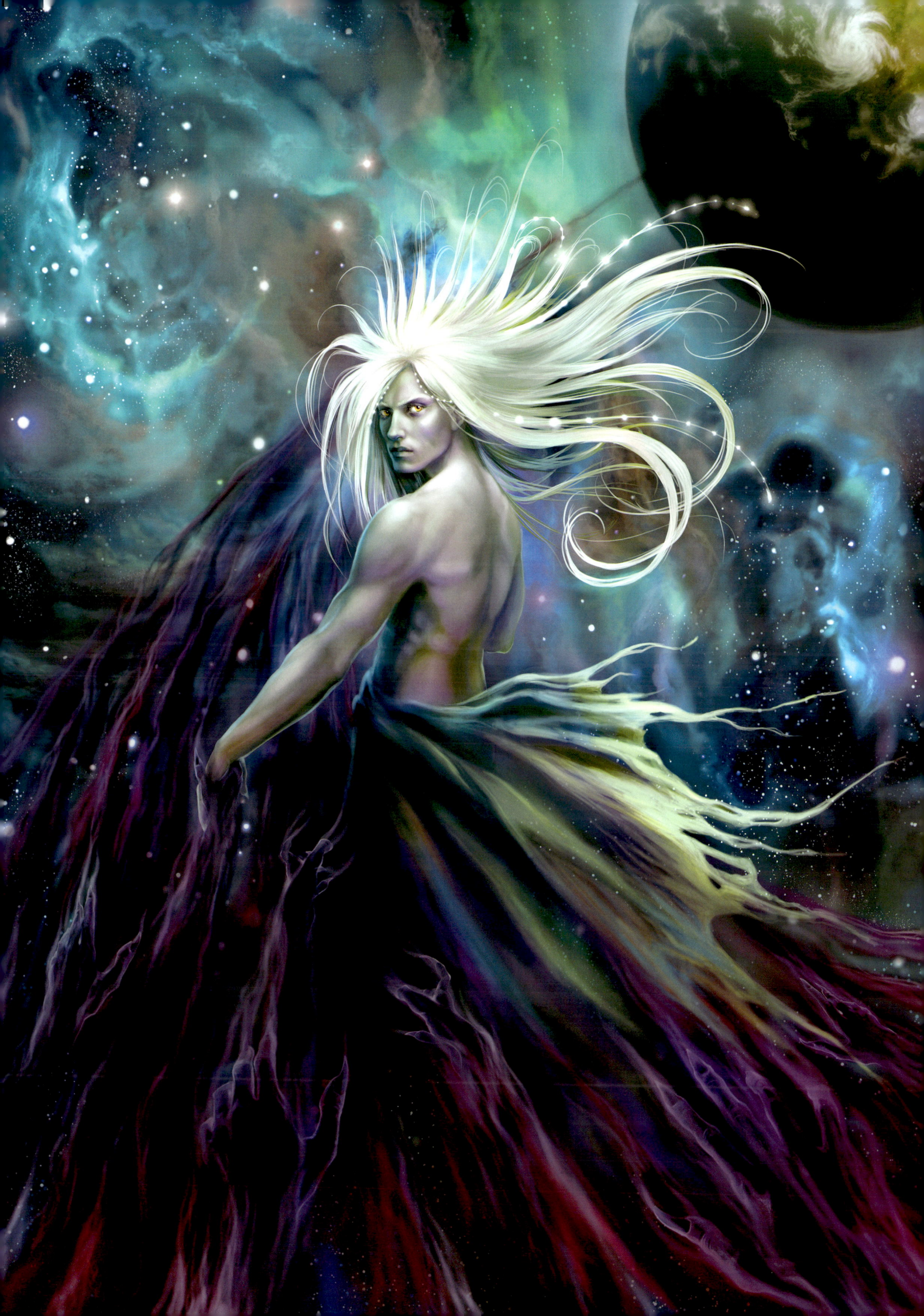

Pearl
Photoshop, Painter
Melanie Delon, FRANCE
[above]

Ghost of Summers Past
Painter
Wen-Xi Chen, GREAT BRITAIN
[above]

Love
Painter, Photoshop
Marta Dahlig, POLAND
[right]

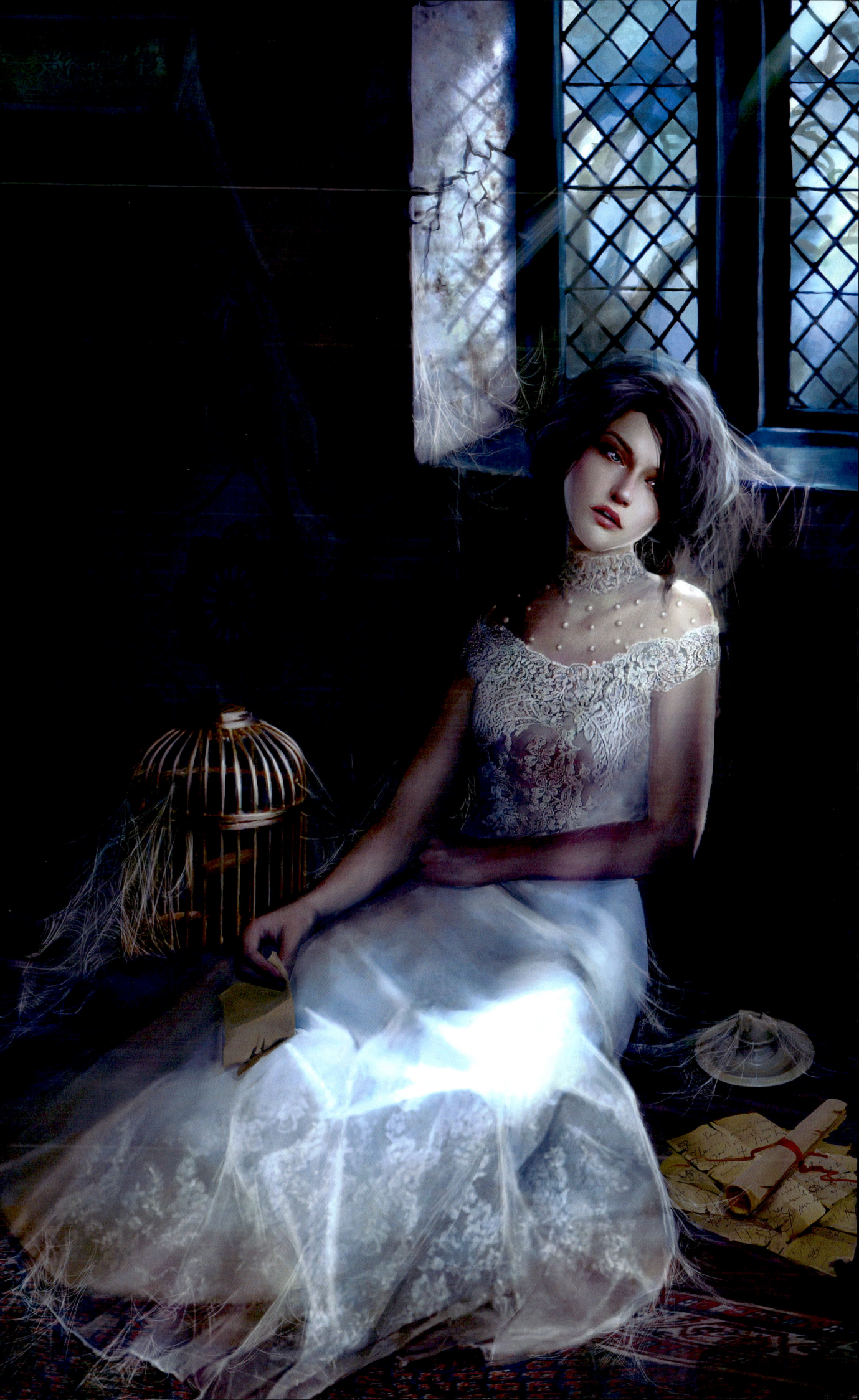

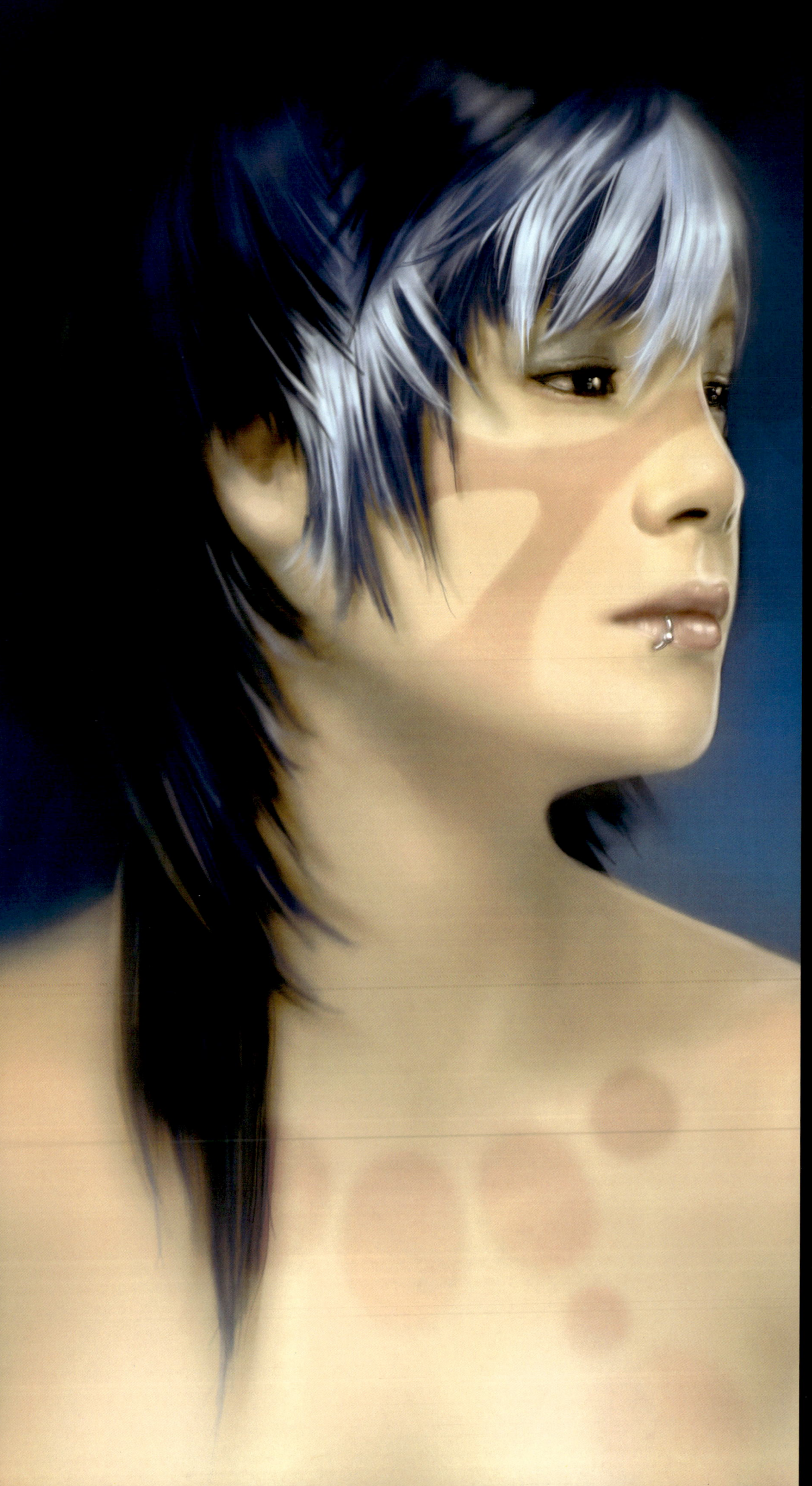

Darker
Photoshop
Vanessa Tam, CANADA
[left]

Moon key
3ds Max
Olivier Ponsonnet, FRANCE
[right]

Banima
Painter
Rafi Adrian Zulkarnain, INDONESIA
[top left]

Svadren Aiden captain
Photoshop, Painter
Tomasz Jedruszek, POLAND
[above]

The unwanted
Photoshop, Painter
Mikko Eerola, FINLAND
[left]

Lucrezia Navarre
Photoshop, Painter
Client: Joe Mander
Benita Winckler, GERMANY
[right]

Slaver
Photoshop

/ **BALLISTIC** /

"Razor Vixen"

SPECIAL EDITION PRINT
from
THE WORLD'S MOST BEAUTIFUL CG CHARACTERS
EXOTIQUE 2

by

J.S Rossbach, FRANCE
Art Director: Shane Hartley
Client: Wizkids

www.BallisticPublishing.com

/ BALLISTIC /

"Sarah Morrison"

SPECIAL EDITION PRINT
from
THE WORLD'S MOST BEAUTIFUL CG CHARACTERS
EXOTIQUE 2

by
Steven Stahlberg, MALAYSIA
Client: NCSoft

www.BallisticPublishing.com

The Pain
Photoshop
Chayanin On-ma, THAILAND

Twilight Tranquility
Photoshop, Painter
Annie Stegg, USA
[top left]

Red Riding Hood strikes back
Painter, Photoshop
Christian Guldager, DENMARK
[above]

Dark Night
Poser, Photoshop
Nikki Kirk, GREAT BRITAIN
[above]

Geisha
Painter
Maria Trepalina, RUSSIA
[top right]

Z
Painter
Hong Kuang,
SINGAPORE

Geisha
Painter, Photoshop, Illustrator
Lian-kai Yang, TAIWAN

永远的悲伤

爱等待在永远的边缘
远到就要被遗忘和丢失
它在远处频频招手

Eternal sorrow
Photoshop
Hoang Nguyen, USA

Chinese
Photoshop
Ying Hol Chan, SINGAPORE
[top left]

Fox lady
Photoshop, Painter
Client: Le 7ème Cercle
Marc Simonetti, FRANCE
[above]

Legend
Photoshop
Ying Hol Chan, SINGAPORE
[left]

QIN 6
Photoshop
Client: Le 7éme Cercle
Aleksi Briclot, FRANCE
[right]

Autoirony
Photoshop, Poser
Grzegorz Kmin, POLAND
[top left]

Turn me off
Photoshop
Japi Honoo, ITALY
[above]

The Watcher
Photoshop
Osvaldo Gonzalez, Pixelium, USA
[top right]

Her Beautiful Life
Photoshop
Alexei Solha, BRAZIL

Green whisper
Photoshop
Nell Fallcard, MEXICO
[top left]

My divine secret
Paint Shop Pro, Painter
Jennifer Reagles, saiaii, USA
[above]

Birth of a soldier
Photoshop
Paul Gerrard, GREAT BRITAIN
[left]

Changing
Photoshop, Painter
Benita Winckler, GERMANY
[right]

EXOTIQUE 2

Hel Mumbling eidolon Koi Blessings

Deliverance
PhotoPaint
Darryl Taylor, USA
[left]

Woman Shaman
Photoshop
Viktor Titov, RUSSIA
[right]

Dragon Conquest
PhotoPaint
Darryl Taylor, USA
[left]

All my hate
Photoshop, Painter
Melanie Delon, FRANCE

Hyksos
Photoshop
Keith Thompson, CANADA
[far left]

Pit Sylph
Photoshop
Keith Thompson, CANADA
[left]

Hiro Nai
Photoshop
Japi Honoo, ITALY
[right]

Lady Isabelle Fredrickson
Photoshop
Min Yum, AUSTRALIA
[far right]

Scribe
Photoshop
Keith Thompson, CANADA
[left]

Susanna
Photoshop, Painter
Mikko Eerola, FINLAND
[top left]

The light of life
Photoshop
DeHong He, CHINA
[above]

Eris
Painter, Photoshop
Michael Chang Ting Yu,
CHINA
[left]

Hush
Photoshop, Painter
Benita Winckler, GERMANY
[right]

J.Pierpont Morgan
3ds Max, Photoshop, ZBrush
Ryan Murray and Dennis Moellers,
Firaxis Games, USA
[top left]

Portraits of old man
3ds Max, ZBrush
Weiye Yin, CHINA
[above]

MVP
Maya, Photoshop
Thitipong 'Pao' Jitmakusol, USA
[top right]

The last elf
Maya, Photoshop
Piotr Fox Wysocki, POLAND
[right]

EXOTIQUE 2

00:22
Photoshop
Borja Fresco Costal, SPAIN
[left]

Lilee
Maya, ZBrush, Body Paint 3D, Photoshop
Udom Ruangpaisitporn, THAILAND
[right]

Strike force
Bryce, Poser, Photoshop
Dean Etheridge, GREAT BRITAIN
[left]

© 2006 Fantasy Flight Games

Raiders of Thenn
Photoshop
Client: Fantasy Flight Games
Kerem Beyit, TURKEY
[above]

Shadowed Vigilance
Photoshop
Amelia Mammoliti, USA
[left]

Gasoline
Painter
Anniina Reimi-Orsa, FINLAND
[right]

Madam Lili Wong
Painter
Maria Trepalina, RUSSIA

Daughter
Painter
Anry Nemo, RUSSIA

Tenshi
Photoshop
Kira Santa, HUNGARY
[above]

Victory Gal
Photoshop
Glen Angus, USA
[right]

EXOTIQUE 2

Dark Phoenix
Photoshop
Client: Activision and Marvel
Glen Angus, USA
[left]

Red sensation
Photoshop
Pierrick Martinez, FRANCE
[right]

Combined forces
Photoshop, Painter, Maya
Steve Argyle, USA
[left]

DE4THF4THER

EXOTIQUE 2

Chuda Ruri
Photoshop
Steve Argyle, USA
[left]

Ebonydragon
Painter
Client: Ebonydragon
Jana Schirmer,
GERMANY
[right]

Jeanne d'Espace
Painter
Christian Guldager,
DENMARK
[left]

Persephone
Painter, Photoshop
Marta Dahlig, POLAND
[far left]

Rapunzel
Painter
Bryan Beus, USA
[left]

Invitations
Painter, Photoshop
Linda Bergkvist, SWEDEN
[right]

In thought
Photoshop
Andreas Rocha, PORTUGAL
[far left]

The African Princess
Painter, Photoshop
Kornél Ravadits, HUNGARY
[left]

Cafe
Photoshop, LightWave 3D
Karl Poulson, USA
[top left]

Arctic beauty
Photoshop
Gina Pitkänen, FINLAND
[above]

What a lovely way to burn
Photoshop
Raffaele Marinetti, ITALY
[left]

The Firstborn
Photoshop
Nykolai Aleksander, GREAT BRITAIN
[right]

Bahamas
Painter
Kei Acedera, CANADA

Maui
Painter
Kei Acedera, CANADA

Ipanema
Painter
Kei Acedera, CANADA

Boracay
Painter
Kei Acedera, CANADA

White rose
3ds Max, Brazil r/s
Koji Yamagami,
Beans Magic Co.,Ltd., JAPAN

Fishing
Photoshop
Sander Kamermans,
THE NETHERLANDS
[above]

Nothing will save me
Photoshop
Melanie Delon, FRANCE
[left]

Fernery
Photoshop
Olga Barkhatova, Acuity,
CANADA
[right]

Kangamole bunny
Photoshop
Bobby Chiu, Imaginism Studios, CANADA
[top left]

Almost cannibalism
3ds Max, ZBrush, Photoshop
Luiz Fernando Rohenkohl, BRAZIL
[above]

Baterpillar farret
Photoshop
Bobby Chiu, Imaginism Studios, CANADA
[top right]

Light bug
Photoshop
Bobby Chiu, Imaginism Studios, CANADA

FinalEducation
Maya, ZBrush, Photoshop
Ralf Stumpf, GERMANY
[top]

Tokyo girl
3ds Max, Photoshop
Andrew Hickinbottom, GREAT BRITAIN
[above]

Metropolis
Photoshop, Illustrator, Painter
Willian Murai, BRAZIL
[right]

Alexandria

Lt. Nelie

Detective St.

Doji
Photoshop
Steve Argyle, USA
[top left]

Qiane
Photoshop
Shreya Shetty, INDIA
[above]

Violet-Black
Photoshop
Nick Deligaris, GREECE
[top right]

The Seven Deadly Sins: VANITY
Painter
Marta Dahlig, POLAND

Burning Heart
Photoshop
Ann-Christin Pogoda, GERMANY
[above]

Healing
3ds Max, Brazil r/s, HDRShop, Photoshop
Hyung-jun Kim, KOREA
[right]

Shadow Within
Photoshop
Client: Norma Editorial
Cris Ortega, SPAIN
[top left]

The dark side of love
Photoshop
Hoang Le, VIETNAM
[above]

Poisoned
Photoshop, Painter
Tomasz Jedruszek, POLAND
[left]

Pirate cutie
Photoshop
Valentin Fischer, GERMANY
[right]

Little Red - Rebel
Photoshop
Michael Chomicki,
StudioQube, CANADA

Yelizveta
Photoshop
Rudy Jan Faber,
THE NETHERLANDS

Joro
Painter, Photoshop
Alex Fang, ACCD, USA

Watchman Kily
Painter, Photoshop
Jiansong Chen, CHINA

Moon Light's bride
Painter
Vadim Leon, LATVIA
[left]

Hopeless reflections
Photoshop
Melanie Delon, FRANCE
[right]

DemonWeavers
Photoshop, Painter
Derek Herring, USA
[top left]

Time of the Faeries: Anavere
Photoshop
Joseph Corsetino, USA
[above]

Bane
Photoshop
Charlene Sun, USA
[left]

Reflecting Pool
Photoshop, Painter
Steve Argyle, USA
[right]

Piper Angel #1
Photoshop
Skan Srisuwan, THAILAND

Monk
Photoshop
Client: Guild Wars
Daniel Dociu, Arenanet, USA
[top left]

The Lizard Man
Painter, Photoshop
Client: Asmodée
J.S Rossbach, FRANCE
[above]

Beast
Photoshop
Yu Cheng Hong, TAIWAN
[left]

The End
3ds Max, mental ray, Photoshop
Matthew Coombe, CANADA
[right]

Red opium
3ds Max
Olivier Ponsonnet,
FRANCE
[left]

Shade
3ds Max
Olivier Ponsonnet,
FRANCE
[right]

Masquerade
Photoshop
Photographer: Katherine Dinger
Lauren K. Cannon, USA
[top left]

Portrait of a serial widow
Photoshop
Roy Stein, ISRAEL
[above]

In a glass darkly
Painter
Art director: Cam Lay
Patrick Jones, AUSTRALIA
[left]

Hisako
Painter, Photoshop
Katarina Sokolova, UKRAINE
[right]

Lullaby
Painter
Wen-Xi Chen, GREAT BRITAIN
[top left]

Plastic Earring
LightWave 3D, Photoshop
Karl Poulson, USA
[above]

Moth and Flame
Photoshop
Christine Griffin, USA
[left]

Confessor
Photoshop
Hoang Le, VIETNAM
[right]

Requiem
Photoshop
Leung Chun Wan, CHINA
[above]

John Doe
Painter
Anniina Reimi-Orsa, FINLAND
[left]

Aquaria
LightWave 3D, Photoshop
Karl Poulson, USA
[right]

Aysha
Photoshop, Painter
Derek Herring, USA
[left]

Knight in the sky
Photoshop
Liu Yang, CHINA
[right]

SoulGardener
Photoshop, Painter
Derek Herring, USA
[top left]

Hunt of the Malesquis
Photoshop
Client: ImagineFX magazine
John Kearney, GREAT BRITAIN
[above]

Red stripes
Photoshop
Nikolay Yeliseyev, RUSSIA
[top right]

Blood elf
3ds Max, mental ray, Photoshop
Ziv Qual, ISRAEL
[right]

Succubi in China Town
Photoshop
Sandra Hirschmann, GERMANY
[left]

Fremen Bloodline
Photoshop
Client: ImagineFX magazine
John Kearney, GREAT BRITAIN
[right]

Afterlife
Painter
Anniina Reimi-Orsa, FINLAND

Necromancer
3ds Max
Olivier Ponsonnet, FRANCE

Titan
Maya, mental ray, Photoshop
Seok Chan Yoo, T-Entertainment Co. Ltd, KOREA
[top left]

Fascination
Bryce, Painter, Photoshop
Isaura Simon, USA
[above]

Sorcerer of inviolable
Maya, Photoshop
Seok Chan Yoo, T-Entertainment Co. Ltd, KOREA
[top right]

Invader
3ds Max, Brazil r/s, HDRShop
Eun-hee Choi, KOREA
[right]

Probes
Photoshop
Simon Robert, ROMANIA

Storm Angel
Poser, Photoshop
Adriana Vasilache, ROMANIA

Octolady
Photoshop
Thierry Doizon, STEAMBOT Studios, CANADA

Cendres
Painter, Photoshop
Client: éditions du Matagot
J.S Rossbach, FRANCE

Katsumi 01
Photoshop
Model: Katsumi
Jean-Yves Lelcercq,
JYL computer art,
BELGIUM
[left]

Pin-up
Photoshop
Rodrigue Pralier,
EA Montreal, CANADA
[right]

Cherry
Poser, Photoshop
Adriana Vasilache, ROMANIA
[left]

Maiko
3ds Max, Brazil r/s
Koji Yamagami,
Beans Magic Co.,Ltd., JAPAN
[right]

The girl next door
3ds Max, Brazil r/s, Combustion, HDRSho
Kanghui Wang, Huoxingshidai, CHINA
[left]

Tristessa
Photoshop
Kira Santa, HUNGARY
[top left]

Kyofu
Photoshop, Maya, Painter
Steve Argyle, USA
[above]

Ryu
Photoshop
Client: RPG.HU
Kira Santa, HUNGARY
[top right]

Nagate
Photoshop
Kira Santa, HUNGARY
[right]

In the white swamps
Painter
Riana Møller,
Nyhedsavisen, DENMARK
[above]

Bloom
Photoshop
Michael Chomicki,
StudioQube, CANADA
[above]

Wired 1.5
Photoshop
Thierry Doizon,
STEAMBOT Studios, CANADA
[right]

Razor Vixen
Painter, Photoshop
Art Director: Shane Hartley
Client: Wizkids
J.S Rossbach, FRANCE
above

Fishhook Girl
Photoshop
W. M. Nelson, USA
[right]

Miss Mars
Photoshop, Painter
Christian Jaeschke, GERMANY
[above]

Miss Bounty
Photoshop, Painter
Christian Jaeschke, GERMANY
[above]

Miss Bacardi
Photoshop, Painter
Christian Jaeschke, GERMANY
[right]

Bonekiller
Painter, Photoshop
Svetlin Velinov,
BULGARIA
[above]

Vampire gunslinger
Photoshop
Art Director: Farzad Varahramyan
Dave Wilkins, High Moon Studios, USA
[top right]

Small geisha
Photoshop
Svetlin Velinov,
BULGARIA
[above]

Gothic innocence
Photoshop
Svetlin Velinov,
BULGARIA
[right]

Mera
Paint Shop Pro, Painter, Poser, 3ds Max
Jennifer Reagles, saiaii, USA
[top left]

Goldenfish Neena
Photoshop
Rafi Adrian Zulkarnain, INDONESIA
[above]

Gold fish
Painter
Jian Guo, CHINA
[left]

China evil slayer
Photoshop
Xiao-chen Fu, CHINA
[right]

AdMemento
Photoshop
Nykolai Aleksander
GREAT BRITAIN
[left]

White Angel
Painter, Photoshop
Jason Chan, USA
[right]

Taurus
3ds Max, VRay
Soa LEE, KOREA

Eirika of Renais
Painter
Client: Strana Igr magazine
Eva Soulu, RUSSIA
[above]

Malander
Photoshop
Client: Aaron Stephens
George Patsouras, USA
[right]

© Nintendo, Intelligent Systems. "Fire Emblem: The Sacred Stones"

Jen
Painter
Josh Nizzi, USA
[left]

Sarah Morrison
Maya, Mudbox, Photoshop
Client: NCSoft
Steven Stahlberg, MALAYSIA
[right]

© Wizards of the Coast

Storm
Photoshop, 3ds Max
Client: Activision and Marvel
Glen Angus, USA
[top]

Simic Guildmage
Photoshop
Client: Wizards of the Coast
Aleksi Briclot, FRANCE
[above]

Neder Hukud
Photoshop, Painter
Tomasz Jedruszek, POLAND
[above]

Sylvan Spirit
Painter, Photoshop
Cyril Van Der Haegen, USA
[top left]

Xyaene: Character Portrait
Photoshop
Ailsa L. MacPherson, GREAT BRITAIN
[above]

Cancer
Painter, Photoshop
Jun-ichi Fukushima, JAPAN
[above]

Deep Sea Creature
Photoshop
Diane Özdamar, FRANCE
[top right]

Ungentle, gentle
Painter, Photoshop
Linda Bergkvist, SWEDEN

Spider warrior
Painter
Kyung Up Hyun, KOREA
[above]

Queen Triffidia - Beauty
Photoshop
Client: ImagineFX magazine
John Kearney, GREAT BRITAIN
[right]

Summer
Maya, ZBrush, Photoshop, Body Paint 3D
Udom Ruangpaisitporn, THAILAND
[above]

Bick's
3ds Max, ZBrush, VRay
Client: Bick's
Richard Rosenman, Hatch Studios Ltd., CANADA
[left]

Foxboy
3ds Max, VRay, Photoshop
Baolong Zhang and Claudio Tolomei,
Climax Action, GREAT BRITAIN
[right]

.birch.
Painter, Photoshop
Hong Kuang, SINGAPORE
[left]

Sylphide
Photoshop
Photographer: Bill Schmoker
Nykolai Aleksander,
GREAT BRITAIN
[right]

Three
Photoshop
Kenneth Yeh, Faceblur Federation, USA
[above]

One
Photoshop
Kenneth Yeh, Faceblur Federation, USA
[above]

Dezicrah
Photoshop
Steve Argyle, USA
[right]

One Thousand Sins
Painter
David Bollt, Tattoo Johnny, USA
[above]

Dear Doctor
Photoshop
Alexei Solha, BRAZIL
[right]

Dr. Freud
Psychologist

Indian
Maya, ZBrush, Photoshop
Adrian Chan, CANADA
[top]

Simulated elegance
Maya, mental ray, Photoshop
Dustin Davis, EA Chicago, USA
[above]

© Image Metrics

Samburu Warrior
Softimage|XSI, ZBrush, modo
William Lambeth, USA

Monique
Photoshop
Mike Hall, GREAT BRITAIN

Passenger
Photoshop, Painter
Joerg Warda, GERMANY

The Victim
Photoshop
Viktor Titov, RUSSIA
[top left]

Follow me
Photoshop
Hui Tian, CHINA
[above]

Sprite Spell
Photoshop
Shinjiro Nobayashi, JAPAN
[left]

The Message
Photoshop, Painter
Mikko Eerola, FINLAND
[right]

Summon Infinity
Photoshop
Lauren K. Cannon, USA
[above]

Goldie
Photoshop
Bao Pham, USA
[above]

Clathrus Ruber Nymph
Photoshop
Diane Özdamar, FRANCE
[right]

Colombine
Photoshop, Painter
Melanie Delon, FRANCE
[left]

Io
Photoshop, Painter
Client: ImagineFX magazine
Benita Winckler, GERMANY
[right]

INDEX

A

Kei Acedera
Toronto, ON,
CANADA
kei@imaginismstudios.com
www.torontostudios.com
88, 89

Nykolai Aleksander
Scarborough,
GREAT BRITAIN
www.admemento.com
87, 156, 173

Scott Altmann
Levittown, NY,
USA
scott@scottaltmann.com
www.scottaltmann.com
30

Glen Angus
Verona, WI,
USA
gangus@ravensoft.com
www.gangus.net
58, 77, 78, 164

Nguyen Antony
Bondy,
FRANCE
nelll_82@hotmail.com
38

Steve Argyle
Orem, UT,
USA
steveargyle@gmail.com
steveargyle.com
8, 10, 14, 78, 82, 100, 111, 142, 175

B

Olga Barkhatova
Acuity
Toronto, ON,
CANADA
olga@artdesigner.ca
www.artdesigner.ca
93

Adam Benton
GREAT BRITAIN
ballistic@kromekat.co.uk
www.kromekat.com
20

Linda Bergkvist
www.furiae.com
4-5, 85, 167

Bryan Beus
Provo, UT,
USA
untitleduser@gmail.com
www.beauxpaint.com
84

Kerem Beyit
Ankara,
TURKEY
kerembeyit@hotmail.com
kerembeyit.cgsociety.org
72

David Bollt
Tattoo Johnny
Boca Raton, FL,
USA
themindseye@mac.com
www.davidbollt.com
176

Aleksi Briclot
Paris,
FRANCE
aleksi@aneyeoni.com
www.aneyeoni.com
53, 58, 81, 152, 164

Giuliano Brocani
Keller Adv
Pontinia, LT,
ITALY
info@giulianobrocani.com
www.giulianobrocani.com
21

C

Von Caberte
PHILIPPINES
von@cabertevon.com
www.cabertevon.com
16

Roberto Campus
Whitingham, VT,
USA
www.robertocampus.com
37

Lauren K. Cannon
Shamong, NJ,
USA
lkcannon@comcast.net
navate.com
118, 184

Juliano Castro
BRAZIL
julianocastro@terra.com.br
www.julianocastro.com
www.animassauro.com
16

Adrian Chan
CANADA
adrianctc@gmail.com
www.adrianctchan.com
178

Jason Chan
Stockton, CA,
USA
jason@jasonchanart.com
www.jasonchanart.com
157

Ying Hol Chan
SINGAPORE
in_house85@hotmail.com
52

Michael Chang Ting Yu
Kowloon, Hong Kong
CHINA
p_spprigan@hotmail.com
www.michaelcty.com
66

Jiansong Chen
Beijing,
CHINA
chain_jane@126.com
www.chainandjane.com
107

Wei Chen
ChengDu,
CHINA
lorlandchen@hotmail.com
flowercity.ppzz.net
34-35
[Cover: EXOTIQUE 2 Special Edition]

Wen-Xi Chen
Cambridge, Cambridgeshire,
GREAT BRITAIN
acid_lullaby@hotmail.com
www.acidlullaby.net
40, 120

Bobby Chiu
Imaginism Studios
Toronto, ON,
CANADA
bobbychiu@imaginismstudios.com
www.imaginismstudios.com
94, 95

Eun-hee Choi
Yong-in, Kyong-gi,
KOREA
hi97bzo@hotmail.com
www.kjun.org
133

Michael Chomicki
StudioQube
Hamilton, ON,
CANADA
yoyo@studioqube.com
www.studioqube.com
106, 144

Matthew Coombe
Toronto, ON,
CANADA
email@mattcoombe.com
www.mattcoombe.com
115

Joseph Corsetino
Los Angeles, CA,
USA
jcorso@artisanimagery.com
www.timeofthefaries.com
110

Borja Fresco Costal
Pontevedra,
SPAIN
dias_de_medianoche@hotmail.com
70

D

Marta Dahlig
Warsaw,
POLAND
blackeri@poczta.onet.pl
www.blackeri.com
41, 84, 101

Dustin Davis
EA Chicago
Des Plaines, IL,
USA
ddavisart@yahoo.com
www.ddavisart.com
178

Sarah Decker
Manitowoc, MI,
USA
sarsa@sarsabess.com
www.sarsabess.com
31

Nick Deligaris
Athens,
GREECE
nick@deligaris.com
www.deligaris.com
100

Melanie Delon
Paris,
FRANCE
esk@eskarina-circus.com
www.eskarina-circus.com
40, 62-63, 92, 109, 186

Daniel Dociu
Arenanet
Redmond, WA,
USA
daniel@arena.net
www.tinfoilgames.com
114

Thierry Doizon
STEAMBOT Studios
Montreal, QC,
CANADA
barontieri@gmail.com
www.barontieri.com
145, 136

E

Mikko Eerola
Helsinki,
FINLAND
einoeerola@hotmail.com
angrymikko.deviantart.com
44, 66, 183

Dean Etheridge
Farnham, Surrey,
GREAT BRITAIN
101637.25@compuserve.com
www.deane.deviantart.com
70

F

Rudy Jan Faber
Boornbergum, Friesland,
THE NETHERLANDS
rudy@rudyfaber.com
rudeone.cgsociety.org
www.rudyfaber.com
106

Nell Fallcard
MEXICO
nellfallcard@gmail.com
56

Alex Fang
ACCD,
Alhambra, CA,
USA
alexfangart@gmail.com
107

Valentin Fischer
Winterbach,
GERMANY
contact@artbyshu.com
www.artbyshu.com
105

Xiao-chen Fu
Hangzhou, Zhejiang Province,
CHINA
krishna860@hotmail.com
www.krishnafu.com
23, 32, 155

188 EXOTIQUE 2

INDEX

Jun-ichi Fukushima
Kashiwa, Chiba,
JAPAN
jun1f@nifty.com
homepage3.nifty.com/
devilkitten
166

G

Paul Gerrard
Cheshire,
GREAT BRITAIN
pgerrard@butterflysoldiers.com
www.butterflysoldiers.com
56

Osvaldo Gonzalez
Pixelium
Miami, FL,
USA
www.pixelium-art.com
54

Christine Griffin
Longwood, FL,
USA
cgriffin@ellenmilliongraphics.com
griffingirl.epilogue.net
120

Alexandria Grossman
Sausalito, CA,
USA
morgannial@gmail.com
153

Christian Guldager
DENMARK
christianguldager@hotmail.com
www.chrisguldager.com
48, 82

Jian Guo
Shanghai,
CHINA
beathing2004@yahoo.com.cn
154

H

Mike Hall
GREAT BRITAIN
mikehall@bluefins.co.uk
squaregg.com
180

DeHong He
Jilin,
CHINA
hedehong1982@163.com
www.hdhcg.com
66

Derek Herring
Littleton, CO,
USA
herring@spiritchasers.com
www.spiritchasers.com
110, 124, 126

Andrew Hickinbottom
Birmingham, West Midlands,
GREAT BRITAIN
chunglist2@btinternet.com
andyh.cgsociety.org
96

Sandra Hirschmann
Villingen-Schwenningen,
GERMANY
www.vanity-circus.com
128

Yu Cheng Hong
Taipei,
TAIWAN
beziermix@yahoo.com.tw
web.my8d.net/digiflyart
6, 114

Japi Honoo
Venezia,
ITALY
motop@hotmail.com
www.japihonoo.com
54, 65

Kyung Up Hyun
Seoul,
KOREA
hku64@naver.com
www.xcomicx.com
168

I

Nathalee Inthavong
Amarillo, TX,
USA
noiinthavong@hotmail.com
24

J

Christian Jaeschke
Bielefeld,
GERMANY
christian.jaeschke@googlemail.com
148, 149

Uwe Jarling
Illertissen, Bavaria,
GERMANY
uwe@jarling-arts.com
www.jarling-arts.com
38

Tomasz Jedruszek
Myszkow, Silesia,
POLAND
info@morano.pl
www.morano.pl
32, 44, 104, 165

Thitipong 'Pao' Jitmakusol
Marina Delrey, CA,
USA
iampao@iampao.com
iampao.com
68

Patrick Jones
Brisbane, QLD,
AUSTRALIA
patrickjjones@optusnet.com.au
members.optusnet.com.au/artinprogress/
118

K

Sander Kamermans
Almere,
THE NETHERLANDS
sander@kamermans.net
www.kamermans.net
92

John Kearney
Wolverhampton, West Midlands,
GREAT BRITAIN
jk@brushsize.com
www.Brushsize.com
129, 126, 169

Chairat Ketnirattana
Dumagute City,
PHILIPPINES
zunchiro@gmail.com
www.y2cool.deviantart.com
18, 19

Hyung-jun Kim
KOREA
kjun.org
103

Nikki Kirk
London,
GREAT BRITAIN
nikkijkirk@hotmail.com
phlox73.deviantart.com
14, 48

Grzegorz Kmin
Otwock,
POLAND
aspius@aspius-art.pl
www.aspius-art.pl
54

Michael Krenzin
Berlin,
GERMANY
micha@bugshub.de
www.bugshub.de
6

Hong Kuang
Singapore,
SINGAPORE
zn@zemotion.net
www.zemotion.net
49, 172

L

William Lambeth
Upland, CA,
USA
williamlambeth@gmail.com
lambethdigital.com
179

Cam Lay
Brisbane, QLD,
AUSTRALIA
members.optusnet.com.au/artinprogress/
118

Hoang Le
Ho Chi Minh,
VIETNAM
aurory@vnn.vn
aurory.deviantart.com
104, 121

Soa Lee
Sungnam-si,
KOREA
soanala@naver.com
www.soanala.com
29, 158-159
[Front cover: EXOTIQUE 2 Softcover edition]

Jean-Yves Lelcercq
JYL computer art,
Liége,
BELGIUM
jyl@swing.be
www.jyl.be
138

Vadim Leon
Riga,
LATVIA
valeon@gmail.com
108

Randy Liu
Arcadia, CA,
USA
darkidnar@hotmail.com
www.ice-and-dark.net/idnar
25

Henning Ludvigsen
3080 Holmestrand,
NORWAY
henlu@online.no
www.henningludvigsen.com
28

M ->

Ailsa L. MacPherson
Staffordshire,
GREAT BRITAIN
www.ailsamacpherson.com
166

Amelia Mammoliti
California,
USA
amelia_stoner@yahoo.com
72

Raffaele Marinetti
Quarto,
ITALY
maraf@raffaelemarinetti.it
www.raffaelemarinetti.it
86

Pierrick Martinez
Onans,
FRANCE
pietrix.m@infonie.fr
www.p-rik.com
79

Gustavo H. Mendonca
Electronic Arts
Burnaby, BC,
CANADA
gus@brushonfire.com
www.brushonfire.com
80

Jerome Moo
Kuala Lumpur,
MALAYSIA
jeromemoo@gmail.com
59

Dennis Moellers
Firaxis Games
Hunt Valley, MD,
USA
dmoellers@firaxis.com
www.firaxis.com
68

Riana Møller
Nyhedsavisen,
Copenhagen,
DENMARK
rmfealasy@hotmail.com
www.fealasy.com
144

< - M

Willian Murai
Arujá, São Paulo,
BRAZIL
whmurai@gmail.com
97

Ryan Murray
Firaxis Games
Hunt Valley, MD,
USA
rmurray@firaxis.com
www.firaxis.com
68

N

W. M. Nelson
Columbus, OH,
USA
master@wmnelson.com
www.wmnelson.com
147

Anry Nemo
Moscow,
RUSSIA
mail@anry.ru
www.anry.ru
23, 75

Hoang Nguyen
Santa Clara, CA,
USA
hoang@liquidbrush.com
www.liquidbrush.com
51

Josh Nizzi
Northborook, IL,
USA
joshnizzi@joshnizzi.com
www.joshnizzi.com
162

Shinjiro Nobayashi
JAPAN
shinjiro.nobayashi@nifty.com
homepage1.nifty.com/
3dreams/index.html
182

O

Chayanin On-ma
Nakhonrachsima,
THAILAND
cha_badang@hotmail.com
www.cha-badang.com
46-47

Cris Ortega
Villanubla (Valladolid),
SPAIN
dark-spider@crisortega.com
www.crisortega.com
104

Diane Özdamar
Orsay,
FRANCE
diane.ozdamar@hotmail.fr
diane.gfxartist.com/artworks
38, 39, 166, 185

P

George Patsouras
Astoria, NY,
USA
slickgreekgeo@hotmail.com
www.mkrevolution.net/art
37, 161

Bao Pham
Iowa City, IA,
USA
thienbao22@hotmail.com
thienbao.deviantart.com
11, 184

Gina Pitkänen
FINLAND
gina@ravnheart.com
86

Ann-Christin Pogoda
Berlin,
GERMANY
wpwebmasterin@web.de
www.darktownart.de
102

Olivier Ponsonnet
Bordeaux,
FRANCE
re1v@free.fr
43, 116, 117, 131

Karl Poulson
Denver, CO,
USA
todd_poulson@excite.com
86, 120, 123

Rodrigue Pralier
EA Montreal
Montreal, QC,
CANADA
rodriguepralier@hotmail.com
www.rodriguepralier.com
139

Q

Ziv Qual
Tel Aviv,
ISRAEL
ziv@zivcg.com
www.zivcg.com
127

R

Kornél Ravadits
Budapest,
HUNGARY
kornel@formak.hu
www.graphitelight.hu
84

Jennifer Reagles
saiaii
Copperas Cove, TX,
USA
saiaii@saiaii.com
saiaii.com
56, 154

Anniina Reimi-Orsa
Helsinki,
FINLAND
anniina@gmail.com
ani-r.deviantart.com
73, 122, 130

Arne S. Reismueller
GERMANY
illustration@reismueller.de
www.comicagentur.de
15

Simon Robert
Reghin, Judetul Mures,
ROMANIA
robikillborn@yahoo.com
www.killborndesign.com
14, 34-135

Andreas Rocha
Queijas,
PORTUGAL
rocha.andreas@gmail.com
www.andreasrocha.no.sapo.pt
84

Paul Roget
Sydney, NSW,
AUSTRALIA
paulroget@bigpond.com.au
www.ostudios.net.au
30

Luiz Fernando Rohenkohl
Marechal Candido Rondon,
Paraná,
BRAZIL
reptor666@hotmail.com
www.reptu.com
94

Richard Rosenman
Hatch Studios Ltd.
Toronto, ON,
CANADA
richard@hatchstudios.net
www.hatchstudios.net
170

J.S Rossbach
Montreuil,
FRANCE
livingrope@hotmail.com
livingrope.free.fr
114, 137, 146
[Back cover: EXOTIQUE 2
Softcover edition]

Udom Ruangpaisitporn
Bangkok,
THAILAND
tucker_3d@yahoo.com
71, 170

S

Kira Santa
Budapest,
HUNGARY
kirasantart@yahoo.co.uk
www.kirasanta.com
76, 142, 143

Jana Schirmer
Leipzig,
GERMANY
jana_schi@yahoo.de
janaschi.deviantart.com
83

Shreya Shetty
Mumbai, Maharashtra,
INDIA
shreyashetty@gmail.com
100

Jonathan Simard
Montreal, QC,
CANADA
capitaine_star@hotmail.com
pikmin.cgsociety.org/gallery/
17

Isaura Simon
Woodside, NY,
USA
isauras@isauras.com
www.isauras.com
132

Marc Simonetti
Annecy,
FRANCE
m.simonetti@laposte.net
www.marcsimonetti.com
52

Alexei Solha
Fortaleza, Ceará,
BRAZIL
pirata_imaginario@hotmail.com
pirataimaginario.deviantart.com
55, 177

Katarina Sokolova
Kiev,
UKRAINE
katarinasokolova@gmail.com
119

Eva Soulu
Moscow,
RUSSIA
soulu@otaku.ru
lamp.otaku.ru
160

Skan Srisuwan
Bangkok,
THAILAND
m_d_temps@hotmail.com
www.fiduciose.com
27, 112-113

Steven Stahlberg
Kuala Lumpur,
MALAYSIA
stahlber@yahoo.com
163

Annie Stegg
Marietta, GA,
USA
anastegg@yahoo.com
48

Roy Stein
ISRAEL
roy_splinter@walla.co.il
www.roystein.com
118

Ralf Stumpf
Müheim Ruhr,
GERMANY
stumpf3d@t-online.de
96

Charlene Sun
Alhambra, CA,
USA
cwsun7@gmail.com
www.art.cwsun.com
110

T

Vanessa Tam
Toronto, ON,
CANADA
vanessactam@yahoo.ca
42

INDEX

Darryl Taylor
Louisville, KY,
USA
kre8tive06@hotmail.com
liquidd-1.deviantart.com
60

Keith Thompson
Ottawa, ON,
CANADA
k@keiththompsonart.com
www.keiththompsonart.com
46, 64

Hui Tian
Beijing,
CHINA
thwork@126.com
www.huitian.org
182

Viktor Titov
Voronezh,
RUSSIA
viktortitov@yahoo.com
61, 182

Claudio Tolomei
ITALY
lordrubino@hotmail.com
171

Maria Trepalina
Moscow,
RUSSIA
to@ketka.ru
www.ketka.ru
48, 74

Francis Tsai
High Moon Studios
Carlsbad, CA,
USA
www.highmoonstudios.com
22, 98

V

Cyril Van Der Haegen
Pawtucket, RI,
USA
tegehel@cox.net
www.tegehel.org
166

Farzad Varahramyan
High Moon Studios
Carlsbad, CA,
USA
www.highmoonstudios.com
22, 98, 150

Adriana Vasilache
ROMANIA
addyredrose@yahoo.com
redragon.deviantart.com
136, 140

Svetlin Velinov
Sofia,
BULGARIA
svetlin@velinov.com
www.velinov.com
7, 150, 151

W

Leung Chun Wan
Hong Kong,
CHINA
onimask@hotmail.com
www.heretic-family.com
33, 36, 122

Kanghui Wang
Huoxingshidai,
Beijing,
CHINA
wangkanghui2005@163.com
www.cgidol.fotoyard.com
140

Joerg Warda
Berlin,
GERMANY
office@warda-art.com
www.warda-art.com
181

Bruno Werneck
USA
contact@brunowerneck.com
www.brunowerneck.com
22

Dave Wilkins
High Moon Studios
Carlsbad, CA,
USA
www.highmoonstudios.com
98, 150

Benita Winckler
Berlin,
GERMANY
benita@dunkelgold.de
www.dunkelgold.de
45, 57, 67, 187

Piotr Fox Wysocki
POLAND
piotrwysocki@op.pl
69

Y

Koji Yamagami
Beans Magic Co., Ltd.
Nakano-ku, Tokyo,
JAPAN
yama@beans-magic.com
www.beans-magic.com
90-91, 141

Fan Yang
Seattle, WA,
USA
jiugefan@126.com
www.yangfanart.com
8, 9

Lian-kai Yang
Pingtung,
TAIWAN
deltachus@hotmail.com
tw.myblog.yahoo.com/
microbe-kai
50, 125

Liu Yang
Meizhou,
CHINA
poisondlo@gmail.com
poisondlo.deviantart.com
125

Kenneth Yeh
Faceblur Federation,
Rowland Heights, CA,
USA
alita359@yahoo.com
174

Nikolay Yeliseyev
Rostov-on-Don,
RUSSIA
nik@yeliseyev.ru
www.yeliseyev.ru
99, 126

Weiye Yin
Beijing,
CHINA
francwork@163.com
FrancCG.51.net
68

Seok Chan Yoo
NAKOinteractive,
Seoul,
KOREA
bbyag3@hotmail.com
132

Min Yum
Melbourne, VIC,
AUSTRALIA
minyum@gmail.com
www.minart.net
65

Z

Vitali Zh.
Budapest,
HUNGARY
vit@vitecrow.hu
www.vitecrow.hu
6

Baolong Zhang
CHINA
george0280@hotmail.com
george0280.cgsociety.org
171

Gracjana Zielinska
Warsaw,
POLAND
vinegaria@gmail.com
vinegaria.com
30

Loïc Zimmermann
Troyes, Aube,
FRANCE
info@e338.com
www.e338.com
16

Weng Ziyang
Wuhan, Hubei,
CHINA
wengziyang@gmail.com
www.danmo.com
12-13, 26

Rafi Adrian Zulkarnain
Bandung, West Java,
INDONESIA
solidgrafi@yahoo.com
rafiadrian.ciptalima.com
44, 154

SOFTWARE INDEX

Products credited by popular name in this book are listed alphabetically here by company.

			
Adobe	Illustrator, Photoshop	www.adobe.com	
Autodesk	3ds Max, Combustion, Maya	www.autodesk.com	
Chaos Group	VRay	www.vrayrender.com	
Corel	Painter, Paint Shop Pro	www.corel.com	
CuriousLabs	Poser	www.curiouslabs.com	
DAZ Productions	Bryce	www.daz3d.com	
Luxology	modo	www.luxology.com	
MAXON	Body Paint 3D, CINEMA 4D	www.maxoncomputer.com	
Mentalimages	mental ray	www.mentalimages.com	
Paul Debevec	HDRShop	www.hdrshop.com	
Pixologic	ZBrush	www.pixologic.com	
Skymatter	Mudbox	www.mudbox3d.com	
Softimage	Softimage	XSI	www.softimage.com
Splutterfish	Brazil r/s	www.splutterfish.com	

EXOTIQUE 2 191

Finest digital art in the known universe

Image courtesy of Eric Ryan

We make the finest digital art books: Be inspired by the world's best digital art and learn how it is done! Ballistic Publishing is an award-winning publisher of high-quality digital art. Our books will inspire and educate you. For 'best of' digital art, take a look at the EXPOSÉ series. If you are interested in tutorial books, our d'artiste series contains master classes by the world's leading digital artists. **Visit: www.BallisticPublishing.com**

/ BALLISTIC /